SALEM'S
WITCH
HOUSE

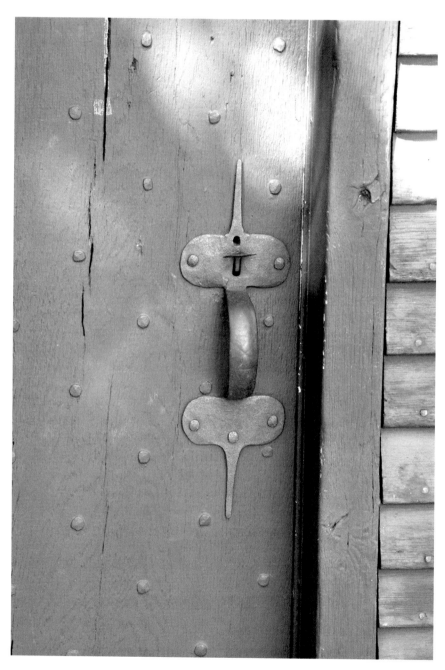

Salem Witch House door handle. *Photograph by John Goff.*

SALEM'S WITCH HOUSE

HOUSE

A TOUCHSTONE TO ANTIQUITY

JOHN GOFF

THE
History
PRESS

Published by The History Press
Charleston, SC 29403
www.historypress.net

Cover image: Clark Goff sketch.
Cover design by Marshall Hudson

First published 2009

Manufactured in the United States

ISBN 978.1.59629.519.3

Library of Congress Cataloging-in-Publication Data

Goff, John V.
Salem's Witch House : a touchstone to antiquity / John Goff.
p. cm.
Includes bibliographical references.
ISBN 978-1-59629-519-3
1. Witch House (Salem, Mass.)--History. 2. Dwellings--Massachusetts--Salem--History.
3. Historic buildings--Massachusetts--Salem. 4. Architecture, Domestic--Massachusetts-
-Salem--History. 5. Salem (Mass.)--Buildings, structures, etc. 6. Salem (Mass.)--History.
7. Dwellings--Conservation and restoration--Massachusetts--Salem--History. 8. Historic
buildings--Conservation and restoration--Massachusetts--Salem. 9. Historic preservation--
Massachusetts--Salem. 10. Salem (Mass.)--Biography. I. Title.

F74.S1G64 2009
974.4'5--dc22
2009033683

CONTENTS

Author's Note

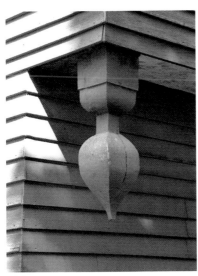

Salem Witch House pendant drop.
Photograph by John Goff.

Because the ancient Witch House at the corner of Essex and North Streets in Salem, Massachusetts, evolved through many different ownership periods dominated by members of Salem's Davenport, Corwin, Ward and other families, many different names have been and could be used to describe the house(s) erected there. Three houses in particular were all first built in proximity for Davenports, Corwins and Curwen kin: the Bowditch House, the Lindall-Gibbs House and the Davenport-Corwin or Corwin House, also known today as the Witch House. Throughout this book, we will refer to the Corwin House or Davenport-Corwin House as the Witch House, because the structure is so closely tied to and associated with the life and legacy of Judge Jonathan Corwin of the Salem witch trials of 1692.[1]

Acknowledgements

Many people assisted in bringing this book into being. The author would like to thank Anna Kasabian, Rachel Roesler and Saunders Robinson with The History Press; Karen Gahagan; and many others. Bonnie Hurd Smith and Bob Booth provided information and inspiration. Jim McAllister, Kathy Simolaris, Elizabeth Seater and Sara Harwood all provided research assistance.

Judy Lazdowski provided help locating various rare Witch House antiques. Staley McDermet, Meg Twohey, Nat Bowditch, Becky Putnam, Ray Shea, Kate van Dyke and many associated with Historic Salem, Inc., provided help with the Bowditch House research and early study of the property.

The author and publishers are also indebted to many others, including but not limited to: Mayor Kim Driscoll of the City of Salem; Representative John Keenan, descendant of Rebecca Nurse, a 1692 witch trials victim; Lorraine Jackson and the staff of the Salem Public Library; Bill Finch and Donna Thorland; Doug Bollen; Biff Michaud and the staff of the Salem Witch Museum; Christine Michelini and the Peabody Essex Museum; Richard Trask; Polly Chase Harrell; John Hardy Wright; Stephen J. Shier; Annie C. Harris, Bill Steelman and the proponents of the First Period Preservation Initiative at the Essex National Heritage Commission; Earl Taylor, Ellen Berkland and fellow founders of the Alliance of First Period Properties in Dorchester and Boston, Massachusetts; the board members of Salem Preservation, Inc.,

preservers and restorers of Salem in 1630: Pioneer Village; Cliff Hersey, K. David Goss and Kristina Wacome Stevick with the Institute for Public History of Gordon College; and Abbott Lowell Cummings, First Period architectural historian. Thank you all!

INTRODUCTION

S alem's ancient Witch House at Essex and North Streets is one of America's most significant historic landmarks. It is also architecturally compelling and intriguing, due to its being so out of step with the twenty-first century. While all around it traffic rushes and people pass, the house itself sits like a silent memorial to and reminder of Salem's earliest days.

Old houses and ancient properties guard secrets, for in many cases the oldest of the family records and memories have been lost or destroyed over the generations and years. Times change and people forget what happened. In the absence of recorded history, myth grows and mysteries multiply.

The primary purpose of this book is to begin the process of reconstructing and narrating the true and ancient history of the Salem Witch House property, while also using the house as a window through which to view Salem's own evolution as a settlement site.

The Witch House in Salem, Massachusetts, is nationally significant for its ties to the Salem witch hysteria and trials of 1692, for its early restoration as a Colonial Revival historic house museum between about 1840 and the 1940s and also for the part it played as a backdrop property to Leslie's Retreat, considered the first armed conflict in the Revolutionary War. In addition, the site itself also predates English settlement to connect with long-ago Naumkeag and a world created and occupied by Native Americans. It also has many ties to maritime Salem as a seaport.

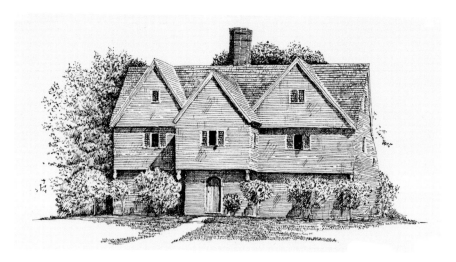

The primal elements of First Period architecture are visible in this 1970 rendering of the Witch House, produced by the author's uncle. *Courtesy of Clark M. Goff.*

Salem's Witch House has many surprising stories to tell. Here we will begin by sharing a few. But to hear them all, it is necessary to visit, view and experience this remarkable colonial and Colonial Revival–style landmark. Be sure to visit Salem and tour the house in person![2]

ANCIENT BEGINNINGS

Before 1626

S alem's wicked cool Witch House at the corner of Essex and North Streets stands on one of the oldest sites in North America. It is a seventeenth-century property that has deep roots in much older times. But why trust my testimony? Consider instead the ancient account provided by Salem's scribe. Hear the words of Nathaniel Hawthorne, who descended from John Hathorne, the seventeenth-century witchcraft judge and the black-robed court companion and in-law of Jonathan Corwin.

Tucked 'tween the covers of his *Twice-Told Tales*, Hawthorne described the Salem spot that stands precisely three hundred paces east of Essex and North Streets, the place that anciently, like the Witch House site, bordered an old east–west Indian trail.

Shawmut (meaning "at the spring"), *Mishawum* ("big spring"), *K't-Ashum-Ut* and *Tashmoo* ("great spring") were fine words spoken here centuries past, as ancient First Peoples, the Massaschusett or Massachuseok, built their campfires, kept their council, honored the Sacred Four Directions and referenced the living waters that eternally and effortlessly bubbled forth at what in more recent years has been called Town House Square.[3]

Hawthorne described the old town pump, later built on the ancient water spring site. He allowed the Salem pump to speak its own story:

> *I will delight the town with a few historical reminiscences. In far antiquity, beneath a darksome shadow of venerable boughs, a spring bubbled out of the leaf-strewn earth, in the very spot where you now behold me, on the*

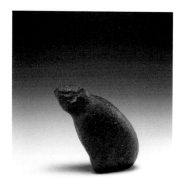

Naumkeag bear. This pre-1620 Native American stone sculpture of a seated bear was found close to Essex Street in Salem. *Courtesy the Peabody Essex Museum.*

sunny pavement [three hundred paces east of the Witch House]. *The water was as bright and clear, and deemed as precious, as liquid diamonds. The Indian sagamores drank of it, from time immemorial, till the fatal deluge of the fire-water* [or war and plagues] *burst upon the red men, and swept their whole race* [mostly] *away from the cold fountains. Endicott, and his followers, came next, and often knelt down to drink, dipping their long beards in the spring. The richest goblet, then, was of birch-bark. Governor Winthrop, after a journey afoot from Boston, drank here, out of the hollow of his hand.*[4]

Fresh water has always been the most prized of earthly possessions. Without it, no human or animal can long live. Long before the natives walked with muffled moccasins the Essex Street footpath toward the Naumkeag or Salem spring, perhaps the path itself was an animal trail that simply led to this place to drink. Here came the deer, the bear, the wolf, the chipmunk, the squirrel and more. Here came Nanepashemet's people to hunt and to fetch water, meat and hides.[5]

See the clock that records the times before 1600. Those were the times of the distant deep, the times in which Salem bloomed and blossomed as Naumkeag or *Naum-ke-ag*, the Native American fishing or fish-processing place. Those were the times when the air was clean, the trees stood tall, the sun beat warmly and the beautiful landscape here was covered with forest, hills, meadows and marsh. Those were the times when the Massachusett or Massachuseok peoples came here seasonally to summer, hunt, fish and farm Indian corn and other crops (such as beans, and *askuntersquash* or squash) in beautifully tended gardens located by the shore of the local rivers and Massabequash or by Salem Harbor itself.

Oh for beloved Naumkeag! Does it still survive in a parallel realm? Generations and generations and generations of people resided here then, cutting the wood to make bent-sapling structures, covered with tree bark and outfitted with woven mats and warm furs. Tall trees were felled with stone tools to make mishoonash, or dugout canoes. Animals such as the deer were hunted with stone-tipped arrows to make hides, clothes and shoes.

In that ancient and fairest Naumkeag, the peninsular east–west land was bounded by two *tegwas*, or tidal rivers, on the north and south. The *shawmut* or spring bubbled forth its clear life-supporting waters near the middle of the peninsula. The trail now known as Essex Street went down the high spine of the land to the spring. Beyond, and to the east, it led to the shore and to the place now known as the Willows, where stone-working and fish-processing was done. Beyond, and to the west, it pointed off toward *Wachusett* (the hill) and the lands of the Nipmuck (fresh water place) people.

Along Naumkeag's old east–west forest floor trail walked the people who viewed most animals as their kin, their advisers and their spirit brothers. Over time, the narrow woods trail was widened to become a cart path, a rural road and then, in more modern times, a paved urban street. The trees were felled to make houses, ships and fences, were used for firewood and were cleared to create farm fields. The old days and old times were almost completely forgotten, until trenches were dug to install new pipes. In the early 1800s, perhaps when Hawthorne was a boy, a man digging a trench pulled up an odd carved rock from near Salem's Essex Street. *Connawa!* It was a bear sculpture, a prized object, from the days before the Witch House—from the days and nights of Naumkeag long ago.[6]

CHAPTER 2

FIRST PERIOD PURITANS

1626–1674

We know from English, French and Native American sources that Nanepashemet's domain here in old Naumkeag suffered serious problems between about 1603 and 1626. These problems were mostly sparked by foreign invasions from the east. In 1603, North America was settled by the first French, while in 1626, Naumkeag was settled by the English.

In the opening decades of the seventeenth century, three related factors severely affected an old Native American trade empire and political kingdom here in Naumkeag, as well as on what is now Boston's North Shore. These were the French fur trade, the Tarratine Wars and plagues and diseases.

Beginning in 1603, the French government under King Henry dispatched a heavily armed Samuel de Champlain to America to develop a new French fur trade. This was undertaken to enrich France and earn new wealth through providing warm fur clothes for all of Europe. After early explorations along the Massachusetts coast, the primary French base was established farther north at Port Royal in Nova Scotia, but the new French presence continued to have effects here.

One of the most devastating effects caused by the new French presence in the early 1600s has been called the Tarratine Wars. To understand these conflicts, one needs to look at the Gulf of Maine region as a whole, from Cape Cod south of Naumkeag and Salem as far north as Nova Scotia and Canada. This entire coastal region was explored by the French and utilized as a basis of a transformative new fur trade.

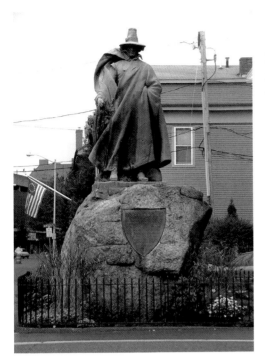

The first English settlers of Salem arrived in 1626. They continued to call the place Naumkeag for a few years. The Roger Conant statue stands near the Salem Common.

In the first decade of the seventeenth century, the Micmac or Tarratines of Nova Scotia became solid fur trade partners and trade intermediaries with the French. They traded beaver pelts and furs to the French for such exotic European commodities as metal knives, copper kettles, guns and gunpowder. In addition, they utilized their knowledge of native ways and traditions to secure additional pelts and wealth from other natives living farther away, such as Nanepashemet and the Massachusett in eastern Massachusetts.

Between about 1607 and 1619, a variety of fur trade disputes, and possibly other factors, caused the Micmac to seek to monopolize the coastal fur trade and eliminate the Massachusett as a trade competitor. The Micmac had significant advantages of nearly unlimited access to French arms and gunpowder, as well as potentially other new technologies, such as French ships, French maps and navigational knowledge.

A series of hostile sea raids were launched by the Micmacs/Tarratines against the Massachusett and their allies in Maine and other points along the New England coast. These raids involved Massachusetts in the Tarratine Wars. They are generally credited with Naumkeag being raided and militarily overwhelmed about 1615 and with Nanepashemet (the leading local ruler) being brutally assassinated on a hill overlooking the Mystic River in modern Medford, Massachusetts, in 1619.[7]

Along with the disruptive military conflicts and wars, a series of highly contagious and deadly pandemics or plagues wrought havoc along the Massachusetts coast and in other areas involved in the Tarratine Wars.

An estimated 90 percent of the traditional strength and population of the Massachuset Nation was destroyed by 1620 by the French fur trade, wars and plagues. Taking advantage of the new depopulations, the English through the *Mayflower* Pilgrims established permanent residence at Plymouth on Cape Cod. The *Mayflower* Pilgrims included such well-known Separatists as William Bradford, Priscilla and John Alden and the military leader Miles Standish.

The people of Salem typically cite 1626 as the first English founding date, because in that year Roger Conant and others moved Cape Ann colony remains from the current site of Gloucester south to Naumkeag. Conant moved the group, which included Thomas Gardner and John Balch, to Naumkeag largely because Naumkeag appeared to offer more natural resources, including fertile farmland, to sustain the growth of a new English colony and town. Conant is honored as the founder of modern Salem, and a large statue of Roger Conant stands today by the Salem Common. Yet because the Cape Ann colony was first founded in 1623, the roots of Salem's English colonization actually go back to that earlier year. Let us provide a slightly more informative account by including the 1623 chapter.[8]

1623 ORIGINS OF ENGLISH SALEM

The 1623 Cape Ann colonization effort was spearheaded by an English group known as the Dorchester Company, or the Dorchester Adventurers. It was based in Dorchester, Dorset, in the West Country of England, near the English Channel. Here, near what was a Roman military town in ancient times (Durnovaria, founded in AD 43), various later tribes established the Anglo-Saxon *Dornwaraceaster*, which over time became Dorchester. By the early 1600s, Dorchester became mostly an English farming and trade center. It suffered from overpopulation, unemployment, poverty and other problems.

REVEREND JOHN WHITE'S INFLUENCE

The charismatic English leader who labored to solve Dorchester's many social problems while also colonizing the Massachusetts Bay Colony was Reverend John White (1575–1648), who served both as rector of St.

Peter's Church in Dorchester, Dorset, as well as rector of Holy Trinity in Dorchester. Mostly forgotten now in Massachusetts, White was a profoundly progressive visionary and a force for good. After he was buried at St. Peter's in Dorchester, Dorset, it was inscribed:

> [Here] *lies the body of the Rev'd John White, M.A. of New College, Oxford…A man of great godliness, good scholarship and wonderful ability and kindness he had a very strong sway in this town. He greatly set forward the emigration of the Massachusetts Bay Colony, where his name will live in unfading remembrance.*[9]

White envisioned a new social order in which the excess population of England's West Country could be shipped to Massachusetts and live under more perfect circumstances, with free public education, Church-controlled alehouses and a high standard of living. A permanent foothold established on the Massachusetts coast would also reduce the costs (and increase profitability) of the fishing business, so new wealth would be returned to Mother England to do more social good through that industry as well.

Reverend John White's older sister, Elizabeth White, also born in Stanton, St. John, in Oxfordshire, married a man named Thomas Gardner Sr. Through the White-Gardner family ties, Reverend White's nephew, Thomas Gardner Jr., was chosen to head up the 1623 Cape Ann colony. Gardner was chief-in-charge of a mostly male fishing station and saltworks at Cape Ann before Roger Conant came in and moved the operation to Naumkeag. Conant, who worked professionally as a "salter" in England, hailed from England's West Country as well. Although he never came to Massachusetts personally, Reverend John White is credited with having encouraged the transition and relocation to Naumkeag in 1626. In 1912, Dr. Charles H. Levermore noted, "[In] the face of failure and discouragement the interest and pertinacity of John White kept alive the settlement, which had removed to Naumkeag, afterwards Salem, and out of this beginning grew the colony of Massachusetts Bay."[10]

Reverend John White labored intensively to find funders and English sponsors of the Massachusetts Bay Colony settlement. Some of White's financial backers in England included Knight Sir Francis Ashley of Dorchester, Dorset; Governor John Endecott; and Christopher and John Conant of East Budleigh, Devon. Christopher and John were two brothers of Roger Conant, and John Conant, like John White, was a church rector.

Because of the earlier efforts, Salem can point not only to 1626 as the year of its first English transplantation and founding on its current site, but also earlier to 1623 and the efforts of the Gardners, Whites and others. They organized the Cape Ann colony, where modern Gloucester, Massachusetts, is situated now. Out of these bold undertakings, English Naumkeag, Salem, and the Massachusetts Bay Colony evolved.

THE FIRST ENGLISH ARRIVE AT NAUMKEAG IN 1626 AND 1628

A review of Salem histories by Sidney Perley and others indicates that Roger Conant's group of transplanted Cape Ann colonists included minister John Lyford, William Allen, John Balch, Thomas Gardner, Walter Knight, Richard Norman, Peter Palfry and John Woodbury. They sailed from Cape Ann to a place on the North River in Salem later called Massey's Cove, located near the foot of Skerry Street, off Bridge Street east of the Salem Common. Some settlers, such as Lyford and Woodbury, relocated to Virginia and England after the transplanting was achieved.

Additional English ships with settlers were dispatched to reinforce the relocated Cape Ann colony in 1628, 1629 and 1630. Descriptions in 1926 of the 1628 expedition make passing references to Reverend John White's strong influence overseas and the fact that after the Tarratine Wars and plague, surviving Massachusett natives in the Naumkeag area became militarily allied with the English Puritans to ward off common potential enemies like the Tarratines (Micmac), Mohawk and French. While the "Old Planters" from Cape Ann established a new Naumkeag foothold on the south shore of the North River, a peaceful allied camp of the Massachusett or Naumkeag natives was located directly across and on the north side of the North River.[11]

Salem's North River therefore attracted both Native American as well as English settlers in the 1620s, and the place called Naumkeag was distinctly multicultural before relations between the two groups strained to a breaking point (and King Philip's War) in the 1670s. After Nanepashemet's death in 1619, the Massachusett Native Americans were governed by Nanepashemet's widow, known to history only as "Squaw Sachem," meaning "Lady Leader." The English settlement, called Naumkeag before 1629, was governed initially by Roger Conant in 1626 but was governed by John Endecott (or Endicott) in and after 1628.

Endicott's interest in Naumkeag was sparked in England by the visit of John Woodbury to England and Reverend John White's promotional work in England's West Country in the 1620s. White was a firm friend of Roger Conant. Settlement of "New England" by White and these early Puritans was advocated for a number of reasons, including to create a more "pure" or perfect English society, as well as to provide a fix for the West Country's overpopulation and underemployment challenges.

John Endicott and others secured an English grant to the Naumkeag settlement and surrounding territory, and Endicott was selected to look after the new holdings. Consequently, in the spring of 1628, John Endicott, with his wife and a band of settlers, set sail for Massachusetts in the ship *Abigail*. This was likely a sturdy timber-framed vessel that sported three masts, mostly rigged with square sails, and was a converted merchant ship. Transatlantic passages in the 1620s typically ran at least two months long and were fraught with many hazards, including potential losses due to shipwreck, pirates, bad weather, running out of supplies and illness.

Fortunately for the development of English Naumkeag and later Salem, the *Abigail* was professionally piloted by a good crew, and the ship arrived safely, landing at Naumkeag on September 6, 1628. Conant and the Old Planters gathered on one shore to receive them, and we are told that Squaw Sachem's Naumkeag natives thronged the opposite shore to witness the arrival. After the *Abigail*'s arrival, the colony was managed by Governor John Endicott.

EARLY SALEM STREETS ARE ESTABLISHED

In 1628, the English redeveloped their settlement at Naumkeag following Endicott's arrival to be something quite different than a huddle of thatch-roofed cottages along the North River, which it first was under Conant, Gardner and others. Under Endicott's direction, it appears the entire Naumkeag peninsula between the North and South Rivers was established more as a large fort or as a military encampment.

Washington Street, a major north–south connector, was laid out in 1628 to be a principal avenue on the peninsula. It was laid out perpendicular to the old Indian trail, which became "Ye Main Street." The two principal streets were designed to intersect by the old *shawmut* or natural spring of water. A defensive fort was established "on the highest land in the central part of the settlement…being situated near…[the more modern] Lynde and Sewall streets [about one hundred paces north and east of the Witch House site]."[12]

MANY ADDITIONAL ENGLISH FAMILIES ARRIVE IN 1629 AND 1630

Salem historians have noted that following the original English settlement efforts of 1626 and 1628, two additional major influxes of new families occurred in 1629 and 1630. In 1629, the ship *Talbot* was sailed to Salem, bringing Reverend Francis Higginson and other families. This ship was directed by Captain or Master Thomas Beecher of England, born about 1600, who grew up in Stepney, Middlesex, England (now a part of London).

After dropping off his passengers in New England in 1629, Beecher sailed back to England, where he helped Governor John Winthrop load supplies for the newly purchased ship *Eagle*, rated at 350 tons, that was acquired from Sir Kenelm Digby, with the assistance of the Puritan Lady Arbella, a descendant of King Edward III. Digby's *Eagle* was then renamed the *Arbella* and designated to be the flagship or "Admiral ship" in a fleet of eleven ships that sailed to Salem in 1630, known as Governor John Winthrop's *Arbella* Fleet.

A NEW PURITAN CHURCH CENTER IN SALEM

The English who first sailed to Salem before 1650 called themselves "Puritans." They sought to purify the English Anglican Church and worked to establish a very simple and Fundamental, Bible-based society in which behaviors were based on a careful reading of scripture. Like many other increasingly oppressed Puritans who then lived in England, they especially feared "Popish" developments in their home country overseas, including advances in Catholicism, which they took to be attacks on their English society and their world.

In the early seventeenth century, England saw many changes and was accompanied by much turmoil as the English Revolution of the 1630s approached. New England was settled, and the Massachusetts Bay Colony was preserved as a Puritan realm, in the Puritans' view, so that the New World could afford a new salvation and become a New Jerusalem to old England. In 1629, the old native place name of Naumkeag was changed to "Salem" (from "Jerusalem," and akin to *Shalom*, meaning "peace") to underscore Salem's status as a new Promised Land for those who believed according to approved Puritan creed. By 1634, a small Puritan meetinghouse was constructed adjacent to the old downtown *shawmut* or spring of water at

Salem's nineteenth-century Daniel Low Building occupies the site of Salem's first Puritan meetinghouse. *Photograph by John Goff.*

what is now Town House Square—on the site where the Daniel Low (First Church) building stands.

Once the Puritans built their new Puritan meetinghouse next to the downtown Salem spring of water, the entire area near what is now Town House Square assumed a certain holy quality. The spring itself was used as a place for infant baptisms. The symbolism of the spring being an ever-flowing natural source of life (akin to the scriptural Word of God also being a source of eternal life) no doubt appealed to the first ministers who preached here. These included the dynamic and progressive Roger Williams, who first ministered in the humble Salem meetinghouse in 1634. In later years, Nathaniel Hawthorne spoke about the early Puritan religious use of the spring:

> *The elder Higginson here* [in this spring] *wet his palm, and laid it on the brow of the first town-born child. For many years it was the watering-place, and, as it were, the wash-bowl of the vicinity,—whither all decent folks resorted, to purify their visages, and gaze at them afterwards—at least, the pretty maidens did—in the mirror which it made. On Sabbath*

days, whenever a babe was to be baptized, the sexton filled his basin here, and placed it on the communion-table of the humble meeting-house, which partly covered the site of yonder stately brick one. Thus, one generation after another was consecrated to Heaven by its waters, and cast their waxing and waning shadows into its glassy bosom, and vanished from the earth, as if mortal life were but a flitting image in a fountain.[13]

Once the earliest Salem and new Massachusetts Bay Colony was administered by a Puritan elite, and the spring and meetinghouse area in Salem's center became considered "sacred ground," leading families built houses in the area. In Governor John Endicott's Salem, one of the most important local families was that of the military-minded Davenports. We need to now consider the Davenports in some depth, because they built the earliest known parts of the Witch House.

THE DAVENPORTS

One of the most influential early families to live and work in seventeenth-century Salem was named Davenport. We first see the Davenports in Salem in 1628—when the place here was still known as Naumkeag. The English ship *Abigail*, as previously noted, arrived in Salem on September 6, 1628, carrying perhaps forty or fifty English passengers, who had embarked the vessel over two months before in Weymouth, in Dorset in the West Country of England. Prominent persons who entered earliest Salem after a voyage on the *Abigail* included Governor John Endicott, Richard Davenport, William Trask, Richard Brackenbury and others.

Richard Davenport, born in England about 1606, was a professional soldier and a military man in the Massachusetts Bay Colony. He was closely associated with Governor John Endicott, who was also highly esteemed as a military leader. We do not know where Richard Davenport first lived while residing in late 1620s Salem; he may have first found lodgings as a guest of the governor. After his arrival downtown in 1628, Endicott ruled that the old Thomas Gardner "Governor's House" from Cape Ann (built about 1623) be dismantled, moved by sea from Cape Ann to Naumkeag and be re-erected in earliest Salem to serve as a new Governor's House here. It stood north of the old *shawmut* on what is now Washington Street.

Richard Davenport's life as a military man had some noteworthy developments. In the 1630s, he married Elizabeth Hathorne (1614–1678),

The Davenports, who first constructed the Corwin or Witch House, were a prominent Massachusetts Bay Colony military family. Richard Davenport lost his life in the King Philip's War Great Swamp Fight in December 1675.

daughter of William Hathorne (b. 1575), and became intimately tied into one of Salem's most well-connected families. Elizabeth Hathorne's older brother, William, became in fact the father of witchcraft judge John Hathorne (b. 1641). So Richard Davenport was an uncle of Corwin's comrade in the court.

Richard Davenport also was close to Governor John Endicott when the famed cross-cutting affair happened with the military ensign or banner in 1634. Davenport was appointed ensign to serve under Captain William Traske on May 13, 1634. He became lieutenant in the Salem train band in 1636–37 and in 1637 was appointed second in command to Captain Traske to lead "all the soldiers" sent against the Pequot Indians in Connecticut to the south. By the 1640s, Richard Davenport was also named "Keeper of the Castle" in Boston Harbor, and he retained that position as a Massachusetts Bay Colony military leader until he was struck down by lightning and died there in 1665.

Although the Davenports evidently lived in Salem only between about 1628 and 1643 (at which time they officially moved to Boston), it appears they long held strong ties to Salem and purchased and kept lands in Salem as well as other places.

Between about 1633 and 1641, Richard and Elizabeth (Hathorne) Davenport's eldest four children were all born in Salem. The eldest two were

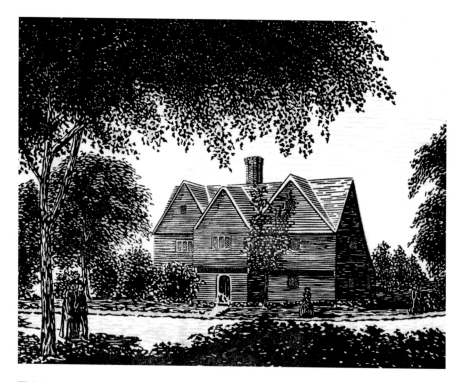

This image, thought to be a circa 1950 linoleum block print of the Witch House, was produced by A. Gaudet. It was labeled "Salem Witch House 1642." Various claims of early seventeenth-century construction persisted until Bryant Tolles noted that the house was simply "pre-1674" in his architectural history published in 1983. *Courtesy Historic Salem Inc.*

son Nathaniel Davenport and daughter Truecross, born in Salem in 1634. Truecross was said to have been named for the Davenport convictions that the "true cross" of the Puritans was an understanding of Christianity and not merely a symbol.

Nathaniel Davenport followed his father's steps into military service. He became one of the first colonial military officers who lost his life to Native Americans while trying to break open a Narragansett Indian Fort in Rhode Island in the first major colonial offensive in King Philip's War in December 1675. The military storming of that fort remains a subject of some controversy. Tefft family traditions maintain that it was designed to be part of a larger colonial land grab—in its arrogance and hostility it was not profoundly different from the circa 1635 banishment of Roger Williams, the 1660s Puritan prosecutions of the Quakers and the 1692 persecutions of the so-called witches in Salem.

While the Davenports played significant early roles in the Massachusetts military—and in first framing up and building the Witch House in Salem probably about 1674—they were almost wholly forgotten in later years. This was largely because after the 1670s the Salem witch trials cut a higher profile in Salem history. The Corwins, associated with the witch trials, became better remembered in connection with both the trials and the house.[14]

CHAPTER 3

TROUBLING TIMES

1675–1691

By the mid-1670s, Puritan Massachusetts found itself in desperate, dangerous and difficult times. For generations, the English settlers had mostly coexisted peacefully with the local Native Americans, who had welcomed or at least allowed their first arrival and planting on the coast. With the Wampanoag (kin of the Massachusett), a solid forty years of peace existed between the early 1620s, when the Plymouth Pilgrims first befriended Massasoit, and the early 1660s, when he died. Yet during the 1660s and 1670s, relations between English colonists and New England natives increasingly became strained, largely because of continuing greed by English colonists for land. Early experiments in peaceful coexistence, such as the maintaining of Native American "Praying Indian" towns around Boston and the positive legacies established by leaders like Roger Williams and Reverend John Elliot, were now acutely challenged.

Years of strain finally erupted in brutal warfare by 1675, with the advent of the Colonial Wars, also called King Philip's War. Following isolated raids on colonial settlements, the Davenports and other Massachusetts military families organized colonial militias to trek south to Rhode Island to rout native strongholds. Both sides suffered deeply as new battles raged.

Although ultimately Puritan New Englanders survived King Philip's War and the English settlements were not wiped from the face of the earth, the wars of the 1670s traumatized Massachusetts colonists for decades. Now equating Indians with "devils" and other "dark forces," Puritan leaders increasingly became paranoid about other possible sources for witchcraft,

demonic forces and disruptions. In many ways, the breakdown in relations between Native Americans and English Puritans in the mid-1670s set the stage and laid the groundwork for renewed survival fears in the 1680s and 1690s, which would crystallize in the Salem witch trials and witch hysteria.

In the same year that King Philip's War first erupted, 1675, a document was prepared and recorded that tells us that the Corwins acquired the Witch House from the Davenports and proceeded to remodel it. The document is an ancient February 19, 1675 builder's contract that described precisely how the house would be altered by stone- and brick mason Daniel Andrew(s) for the family of Jonathan Corwin. The Corwins purchased the house from "Capt. Nath'll Davenport of Boston."[15]

The builder's contract allows us to view several sharp late seventeenth-century ironies. On one hand, optimism prevailed, and the newer house owners, the Corwins, began to improve the older timber-framed Davenport House by expanding and modernizing it. Yet, against this optimism, we see that a background climate of fear seized Salem during King Philip's War and that the late seventeenth century was a period of great human losses, due to the war and other crises.

Before Mr. Andrews was hired to improve the house, the Davenport House was (then as now) a two-and-a-half-story English timber-framed house. The 1675 contract reveals that it had at that time just four major rooms (two each on the two principal floors). It also had a substantial kitchen on the north side that measured twenty feet long and eighteen feet wide. In addition, it had an attic or garret and it had a projecting front "porch" that likely faced south.

In 1675, Daniel Andrews was hired by the Corwins at the cost of fifty pounds English currency, a significant sum, to effect ten major changes and improvements. Andrews was to first dig and provide a stone-walled cellar of six-foot height beneath the East Room. He was also to provide stone underpinning to the porch and kitchen and to build stone steps rising to the porch. In addition, he was hired to build stone steps in two places leading down into the new basement.

Within the house, Andrews was also hired to make significant changes to the chimneys. Specifically, he was to take down "chimneys [flues?]" then standing. He was to rebuild chimneys with five new fireplaces—two on the first floor; two on second floor; and one in the garret. He was also to build one chimney with an oven and "furnace" for the kitchen. He also contracted to provide Dutch tiles for jambs of fireplaces in second-floor chamber rooms and to provide "filling, plastering and finishing" within the house interior.

The 1675 contract was used by some historians in 1870 to suggest that the Witch House was quite old in 1675—and thus most likely the "House of Roger Williams [from] 1635." However, more recent scholarship determined that Roger Williams, Salem's early minister, resided closer to the meetinghouse and spring, east of the Witch House. All we can honestly deduce from the early contract is that the timber frame and other timber parts of the Corwin House were originally built before 1675 (and thus in 1674, or earlier) for Nathaniel Davenport or an earlier owner. But who was the new owner, Jonathan Corwin?

The Corwins

Salem merchant and witchcraft judge Jonathan Corwin (b. 1640), who hired Daniel Andrews to remodel the Davenports' residence in 1675, descended from a noteworthy English family. With a last name spelled variously as Corwin (in America) or Curwen (in England), the family hailed from the northwest part of England, near the Scottish border, in Workington, Cumbria, also called Cumberland. There they descended from Sir Gilbert Culwen II, a knight with King Edward I.

Workington Hall, the ancient familial seat of the Salem Corwins, survives today as a huge stone castle ruin. The Heritage and Arts Unit of the Regeneration Centre on Oxford Street in Workington explains:

> *The Curwen family, who are well renowned in the County of Cumbria, has occupied the site of Workington Hall since the early 13th century. Once a great manor house, the Hall was left to fall into a state of disrepair... The building today contains 18th century ruins, the remains of a Tudor Mansion and the original fortress of the 14th and 15th centuries.*[16]

An English plan or map of Workington Hall shows it to be a large west-facing stone structure with a courtyard at its center. The gatehouse end on the west and parts on the east survive from circa 1362, while near the southeast corner, one particularly thick walled part is a "Justices Hall" that dates from the fifteenth century. It would appear that the Curwens' high social standing overseas gave them court and judge or justice positions in old England as well. English traditions maintain that in the fifteenth century Workington Hall became the site of the manor court. Because the Curwen family were Lords of the Manor, they held

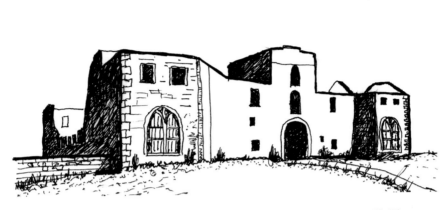

The Corwins or Curwens came from a prominent English family. Workington Hall in Workington, Cumbria, England, was their ancestral family home. *Sketch by John Goff from English photographs.*

all jurisdiction for the area. Within parts of Workington Hall, sentences were passed against wrongdoers.

Due to their high social standing and association with the judicial system in England, the Curwens' Workington Hall was used in the early seventeenth century as a manor court, containing a jail with stocks in the cellar. Tradition held that in 1606 the Workington Hall jail achieved the status of a dungeon, and at one time over one hundred prisoners were squeezed into one very small space. Parallels would be found later in Salem, when the Corwins also achieved significant court positions, and the Witch House would reportedly be used for examining some of the suspects associated with the 1692 Salem witch trials.

How did the Salem Corwins maintain ties with old England? From Sir Gibert Curwen, the Salem Corwins descended through Henry Curwen, born in 1540. It has been noted that Sir Henry Corwin "and his family welcomed...[the Catholic] Mary Queen of Scots" to Workington Hall. Although she gave the Curwens a small agate wine cup as a token of gratitude for the hospitality, Mary (1542–1587) was arrested after staying with the Curwens and was executed by her sister Queen Elizabeth. Court life, though formal, could be filled with intrigue, deceptions and harsh judgments.

Henry Curwen's grandson, George Corwin, was the first to flee to America. Born in 1610, he clearly sympathized with the Puritan cause. In 1636, he married Elizabeth Herbert of Northampton, an English mayor's daughter.

Through an earlier marriage to a John White, born in 1610 (and through Elizabeth's children from that earlier marriage), George Corwin secured ties to the Gardners and Whites, who planted the Cape Ann colony and English Naumkeag. George and his wife Elizabeth sailed to Salem in 1638.

In 1800, Salem's esteemed diarist Reverend William Bentley described how George Corwin immediately moved to the top of Salem society:

> *Captain George Curwin…came here in 1638 with his family, and* [he] *was rich. He was often engaged in town affairs and commanded a troop of horse. He was also a representative in the General Court.* [As his surviving portrait suggests]…*He had a fine round forehead, large nostrils, high cheek bones, and gray eyes…He left no debts, and one of the largest estates that had been administered in the colony, amounting to* [nearly six thousand pounds sterling English currency].[17]

George Corwin prospered as a Salem shipbuilder, merchant and importer of London goods. Following his arrival in Salem from England, George Corwin (also called Captain George Corwin) and his wife Elizabeth raised five privileged children in Salem: John Corwin, born 1638; Jonathan Corwin, born 1640; Abigail Corwin, born 1643; Hannah Corwin born 1643; and Elizabeth Corwin, born 1648.

In 1663, when Jonathan Corwin was just twenty-three years of age, his younger sister Abigail married Eleazer Hathorne (1637–1672), an older brother to John Hathorne, the fellow witchcraft judge. It is possible that the Corwins first heard about the Davenport House (Witch House) being for sale because the Davenport and Corwin families were, in fact, in-laws after Abigail's marriage.

JONATHAN CORWIN'S SALEM AND BOSTON

Writing in the 1870s, Corwin family genealogist Edward T. Corwin noted: "Jonathan…[Corwin]…b[orn] at Salem, Mass., November 14, 1640…was conspicuous for energy and influence, holding high judicial and political positions, and being all his life clothed with public trusts."

Although few records have been found to describe Jonathan's upbringing in detail, it appears through his father's shipping and mercantile connections that Jonathan Corwin grew up during the 1650s and, by the 1660s, had an intimate knowledge of the working waterfronts of both early Salem and

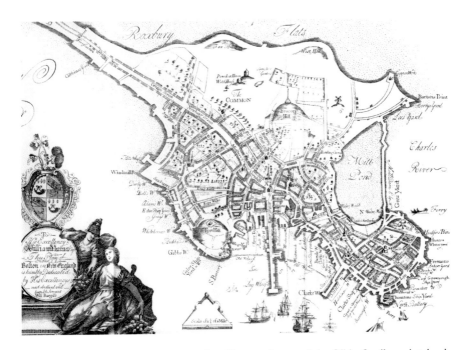

The Corwin and Gibbs families were related by marriage, and the Gibbs family maintained a wharf and a mansion in Boston, fifteen miles south of Salem. *Bonner Map courtesy Dorchester Historical Society, Boston, Massachusetts.*

The Gibbs family wharf was located near Boston's Fort Hill, to the left of Long Wharf as Boston was approached by water. Here we see the wharf called out in a 1728 edition of a Bonner map of Boston. *Bonner Map courtesy Dorchester Historical Society.*

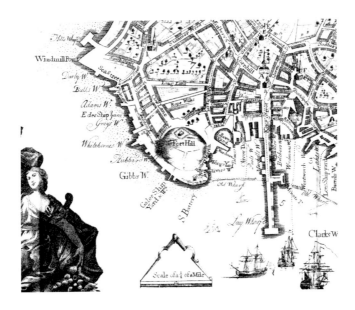

Boston. Jonathan's father George had owned and maintained a number of ships, such as the *George, Swallow, John* and *William*, which pursued coastal trade with Boston and other ports. In 1656, when young Jonathan was but sixteen and possibly apprenticing in a mercantile career, it was recorded that

> *Captain George Corwin* [Jonathan's father] *discovered two Quakers aboard his ship, the Swallow, that had at the time been anchored in Boston Harbor. The two Quaker heretics had been arrested at once, inspected for marks indicating that they were witches, and then sent back to the ship to await deportation.*

Along with learning the ropes of a new career, young Jonathan was also no doubt learning how to be afraid of foreign threats and where to draw the line in order to maintain proper order for the daily functioning of Puritan society. At a time when behavior was as mandated in scripture, and judgment was as dictated by theocratic leaders, nonconformists such as Quakers, Antinomians, Catholics and others were all seen to be potential "witches" or in league with the dark forces, potentially plotting to overthrow godly Puritan society.

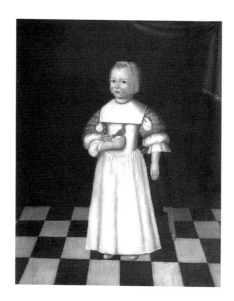

Portrait of Henry Gibbs, 1670, oil on canvas. *Collection of the Clay Center for the Arts and Sciences of West Virginia; gift of Mrs. David M. Giltinan Sr., 1995.*

ELIZABETH SHEAFE

About 1675, Jonathan Corwin, then thirty-five, had the great pleasure to meet the beautiful widow Elizabeth Sheaf(e) Gibbs (1644–1718, roughly) of Connecticut and Boston. Born in Hartford, Connecticut, about 1644, Elizabeth was some four years younger than Jonathan and wealthy by inheritance but widowed. A daughter of import merchant Jacob Sheaf(e) of Boston, Elizabeth had been married to Colonel Robert Gibbs of Boston (1634–1674, roughly). He was a son of the English knight Sir Henry Gibbs of Devonshire, England, and was also

involved with importing seventeenth-century goods from England and Europe to Boston, trading with New London, Connecticut, as well.

While married to the colonel, Elizabeth occupied one of the grandest mansions in seventeenth-century Boston, which in 1671 was placed in trust for her and her children. It was built in the 1660s on Fort Hill. Fort Hill overlooked Boston's great South Bay, which is now mostly filled but survives slightly as Fort Point Channel. In 1663, the English gentleman John Josselyn traveled from London to Boston. At that time the "stately edifice...built by the shore by Mr. Gibs, a merchant" was one of Boston's most noteworthy landmarks. The extravagantly priced Gibbs Mansion (said to cost about three thousand pounds sterling to build) was reportedly built primarily with money that Elizabeth Sheafe Gibbs inherited from her father. The urgent upgrades and remodelings made to Salem's Witch House in February 1675 were likely done to make the smaller country residence more attuned to the high-class tastes of Elizabeth Sheafe Gibbs. Elizabeth and Jonathan evidently fell in love between December 1674 (when Robert Gibbs died) and 1676, when the two married. In Boston, it appears that Jonathan Corwin found a new "First Lady" to head his Salem household.

ELIZABETH'S CHILDREN—FIRST BLOOMS

One can only imagine what both Elizabeth and Jonathan were thinking before they decided to marry. Elizabeth no doubt saw Jonathan as a handsome, active and intelligent Corwin from Salem, who came from a successful line of merchants—like her own father, and her late first husband, Colonel Robert Gibbs. She wanted not only a new husband but also a fine father for her growing young sons, Robert and Henry Gibbs. For his part, Jonathan Corwin likely sought love, success and a new family of his own—and by marrying widow Gibbs, he instantly could capture all three.

Elizabeth Sheaf(e) Gibbs did have at least two, if not three, small children by her first husband—and, incredibly, a rare seventeenth-century portrait survives of the youngest boy, Henry Gibbs. In the fine Puritan painting, little Henry (1669–1723) wears an outfit that looks much like a woman's dress—which was the preferred costume for small boys in his day. He stares straight at the viewer, holds a small bird (likely indicating gently disposition) and stands upon a checkerboard floor painting of blue and white squares. The portrait was labeled "AE 1-1/2, A.D. 1670," indicating that Henry was

just one and a half years old when the painting was commissioned (it was produced in Anno Domini 1670, or 1670 in the Year of Our Lord).

The blue and white color scheme in the painting (as well as its dark, dramatic background) could hint that Elizabeth Sheafe Gibbs was a lady of refined Dutch taste—quite possible, considering that Cranbrook in Kent, the old homeland of the Sheafes, lies in East Anglia not far from Holland. From the Flemish and Dutch the Kent folk imported many families (including the Sheafes), as well as windmills and the broadcloth manufactory.

From what we know of the Sheaf family background in England, it appears that the English coat of arms for this family displayed three whisps or "sheafes" of wheat shown against a blue field. Elizabeth's paternal great-great-grandfather was Richard Sheafe of Cranbrook in Kent (1505–1557), who married Elizabeth Andrews, born about 1515. It is possible that the mason Daniel Andrew or Andrews, hired to upgrade the Witch House, was also a distant kin of Elizabeth's.

Unfortunately, we know very little about Henry Gibbs, depicted in the painting. However, sources inform us that he graduated from Harvard College in 1685. He became a minister in Watertown, Massachusetts, not far from Boston. About ten days before he was to wed Mercy Greenough of Boston in 1692, he traveled north to Salem Village to view the public examination "of criminals (witches)." This boy, the stepson of Judge Jonathan Corwin, later confessed in his diary:

> *1692, 30th May. This day I traveled to Salem. 31st. I spent this day at Salem Village to attend the publick examination of criminals (witches), and observe remarkable and prodigious passages therein. Wondered at what I saw, but how to judge and conclude am at a loss; to affect my heart, and induce me to more care and concernedness about myself and others, is the use I should make of it.*[18]

Young Henry was so well grounded, so spiritual and concerned about the well-being of others, history records that he personally prevented the witchcraft hysteria from spreading south into Watertown, Massachusetts, where he was influential, in 1692–93. Perhaps from his mother little Henry Gibbs inherited more loving and open qualities, rather than the more pointed judgmental qualities of his step-father, the witchcraft judge.

Elizabeth's Children—Second Blooms

Taking Jonathan Corwin to be her second husband in 1676 afforded Elizabeth a chance to start over and a chance to heal the pain suffered by her husband's recent loss.

Almost immediately, Jonathan and Elizabeth focused on filling the Corwin House at Essex and North Streets in Salem with young Corwin children, as well as Gibbs boys. At first, three new Corwin children brought lots of fresh faces and laughter into the house: Elizabeth Corwin was born in 1678; Sarah Corwin was born in 1680; and George Corwin was born in 1683.

It would appear that the eldest and youngest of these three new children were named, respectively, for Elizabeth Sheafe Gibbs Corwin herself, and Jonathan's father, Captain George Corwin, who was quite elderly in 1683 and who died soon after when the new boy was but a toddler in 1685.

Dark Clouds

Although the young baby boy George Corwin brought an abundance of new smiles and cheer into the Corwin-Gibbs House in Salem in 1683, many dark clouds began appearing in the Corwins' lives starting about 1684. Were one a devout Salem Puritan, accustomed to looking for God's favor and displeasure in the world's manifestations, these clouds were more than clouds. They were potentially signs of displeasure, if not something worse—a curse.

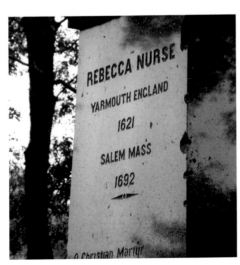

A granite memorial for Rebecca Nurse stands in Danvers, Massachusetts, on the Nurse Homestead property. *Photograph by John Goff.*

Judge Jonathan Corwin and his lovely wife Elizabeth Sheaf(e) Gibbs intended to have additional children after 1684, yet clearly such was not part of God's plan. Jonathan and Elizabeth had five new Salem children between 1684 and 1690—all of them died young.

The pattern was clear: John Corwin, born 1684, died young; Margaret Corwin, born 1685,

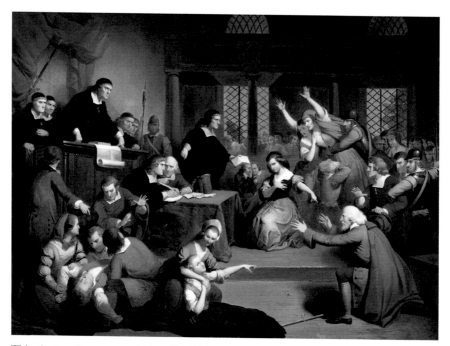

This nineteenth-century painting *The Trial of George Jacobs* was produced in 1855 by artist Thompkins H. Matteson to recapture the drama of the 1692 Salem witch trials. *Courtesy Peabody Essex Museum.*

The Corwin family suffered many deaths prior to 1692 and in the early eighteenth century; this is a view of a stone in Salem's Charter Street Burial Ground. *Photograph by John Goff.*

died young; Anna Corwin, born 1687, survived longer than her siblings but died young at age nineteen in 1706; Jonathan Corwin Jr., born 1689, died young; and Herbert Corwin, born 1690, also died young.

John, Margaret, Jonathan and Herbert: death, death, death and more death. What pain and hurt must have seared the parents. What doubts and concerns these deaths must have raised—especially coming so soon after the cumulative losses of King Philip's War and the death of Colonel Robert Gibbs. With multiple deaths at home and within the Corwin family, and additional significant stresses outside the home, the stage would be set for 1692. Some of the larger colonial concerns in the 1680s included fear of loss of English charter, repression of colonial freedoms under Sir Edmund Andros and news of renewed Indian wars in Maine.

INTENSE EVENTS AND THE ILLUSIONS OF 1692

S alem's Witch House, considered a "mansion house" in its day, is locally, regionally and nationally significant as the only surviving structure in Salem, Massachusetts, known to preserve direct ties to the infamous Salem witch trials and hysteria of 1692. Remodeled to display a complex, multi-gabled form for the prominent Corwins, who descended from the Curwens of Workington Hall, the Witch House was built to display worldly status in early New England. At a time when the Corwin family was intimately involved with many court and colonial administrative matters in late seventeenth-century Salem, Jonathan Corwin, who resided here, was a witchcraft judge charged with determining the truth or falsehood of various witchcraft accusations leveled against many fellow citizens of Puritan Massachusetts.

Judge Jonathan Corwin oversaw many of the Salem witch trials proceedings, along with John Hathorne and others. Some of the initial pretrial examinations of witchcraft suspects for telltale "Witch Marks" reportedly occurred in some of the rooms of the Witch House when it was first located approximately thirty-five feet east of its current location. In 1983, Salem architectural historian Bryant Tolles, in *Architecture in Salem*, noted that "many of those suspected of practicing witchcraft were brought to the house for pretrial examination."

Jonathan Corwin's nephew, George Corwin, also cut a high profile in Salem's 1692–93 witch hysteria years. He was a sheriff involved with arresting many of the accused and bringing them to the "Gaol" (jail), or Salem Witch Jail that formerly stood near the current intersection of

The Salem witch trials of 1692 attracted renewed attention as their bicentennial approached in 1892. *Courtesy Danvers Archival Center.*

Federal and St. Peter's Streets in downtown Salem.

Salem historian Jim McAllister further noted that Judge Corwin's contractor and mason Daniel Andrews, who helped remodel the house in 1674, was also eventually "accused of witchcraft and escaped almost a sure death by fleeing to Europe." As a consequence of all these associations, the ancient Davenport and Corwin House, now called the Witch House, came to be viewed as an important landmark in Salem's seventeenth-century witch hysteria history. It is appreciated today as Salem's only surviving seventeenth-century structure known to have direct ties to the tragedies of 1692.

1692: The Causes of the Events

What precisely happened in 1692 to start the famed witch trials? To this day, historians do not know precisely why the Salem witch trials and associated outbreak of fear and persecution occurred here when it did. We know that many intense events occurred, but because the subject is so mysterious and the legitimacy of the witchcraft trials was later dismissed, we can infer that people were subject to great delusions and illusions in 1692. Judges were deluded and misled to believe that some citizens were horribly possessed when in fact they were not.

Several theories have been proposed to explain the phenomena of 1692, including ergot poisoning, a clash between farming and maritime cultures, stress in Puritan society and an undercurrent of problems with Native American relations that dated back to King Philip's War and earlier decades. The latter two factors were likely most responsible and so shall be discussed further below.

Students of seventeenth-century Puritan culture have long suggested that the outbreaks and problems that affected Salem and Salem Village in 1692 are best understood simply as a consequence of seventeenth-century Puritan theological beliefs and struggles to uphold those beliefs in challenging times. To a people who proposed that they were "Saints" in a corrupt and devil-occupied land, most worldly conflicts and challenges were perceived to be a product of a struggle between forces of Good and Evil. When setbacks (such as loss of a colonial charter, financial struggles or Indian wars, etc.) occurred, they were perceived as being "evidence" of Satan's growing influence—particularly troublesome in a Massachusetts Bible commonwealth. Proceeding logically according to these beliefs, Satan's agents—including witches—would have to be located and eliminated to restore good fortune and divine favor.

In 1675–76, all the English settlements in Massachusetts fought bitterly for their continued existence in the so-called King Philip's War. King Philip was the English name given to Metacom, son of Ousamequin or Massasoit, the Wampanoag Indian leader who befriended and protected the Plymouth Pilgrims in 1620. By the 1660s and 1670s, floods of arriving English settlers caused huge increases in English land-takings, oppressing and dispossessing Native Americans who hunted, fished and farmed Massachusetts long before the first English arrived.

The natives sought to push the English back into the sea and to reclaim lost lands—and a deadly war between natives and non-natives took heavy psychological and physical tolls on both populations. After the 1670s war, victorious English colonists had become so fearful of Native Americans that they shipped many native war survivors off to become slaves in the West Indies and considered all others to be "Black Devils." Only in quite recent years have some Massachusett or Wampanoag natives on St. David's

The 1692 witch hysteria began in the household of Reverend Samuel Parris. Here we see a list of the people who formed his church's congregation. *Courtesy Danvers Archival Center.*

Island in Bermuda been reunited with their Massachusetts kin after more than three hundred years of separation.

Renewed Indian wars in Maine in the early 1690s sent shock waves into Massachusetts and rekindled deep fears that Satan's influence was again increasing. The whole notion that Salem's problems of 1692 may have been aggravated by interracial tensions and cultural misunderstandings is supported as well by observations that one of the key figures in the unfolding 1690s events was Tituba, married to "John Indian." Tituba herself was reportedly of Arawak Native American origin and had been brought to Salem Village by Reverend Parris from the West Indies.

1692: EVENTS AND ILLUSIONS—WHAT WAS SEEN

Salem's famed witch hysteria of 1692 commenced a few miles away from downtown Salem in what was then Salem Village (now Danvers), a quiet farming community. In January and February of the fateful year, two little girls in Reverend Samuel Parris's household practiced something forbidden in Puritan times and a Bible-based community: telling their fortunes by the fire in the Salem Village parsonage. They broke an egg white into a glass of water with an intent to learn the profession of a future husband. The reverend's daughter, Betty Parris, was nine. Her cousin, Abigail, was eleven years old.

After the shape of a coffin appeared in the glass, both girls went into fits and convulsions. They could not speak, their throats choked and "their limbs [became] wracked and tormented." Before long, two other girls, Ann Putnam (age twelve) and Elizabeth Hubbard (age seventeen), also started exhibiting odd symptoms. Neighbors and spectators began to suspect that all of the girls were bewitched.

In the folk wisdom–infused society of the late seventeenth century, medical science was primitive and superstitions abounded. To test the suspicion that the Hubbard, Putnam and the Parris girls were bewitched, two actions were advanced. A medical doctor, Dr. William Griggs, was called to examine the afflicted girls—and after doing so, he declared they were "under an evil hand." A more vernacular means of discerning the truth was also employed when Reverend Parris's two Native American slaves, Tituba and John Indian, were directed to bake a "witch's cake" to be fed to a dog. The cake would have to contain urine of the afflicted girls, and if the dog that ate the cake died or also went into fits, it would be considered proof that the girls were bewitched.

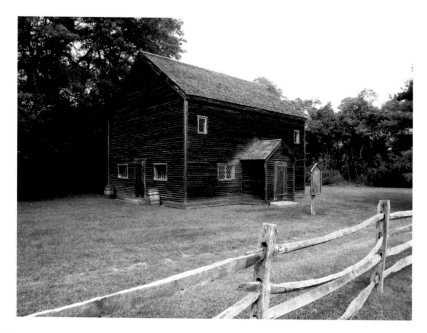

From early drawings and other data, it is believed that the 1692 meetinghouse in Salem Village (Danvers) looked much like this replica, now standing at the Rebecca Nurse Homestead in Danvers. *Photograph by John Goff.*

Frank Cousins took this late nineteenth-century picture of the original seventeenth-century Salem Village (Danvers) meetinghouse site. *Frank Cousins photo, courtesy Stephen J. Schier.*

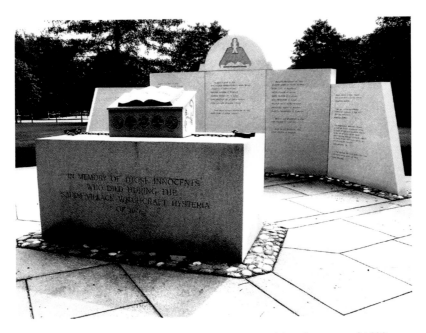

Danvers (formerly Salem Village) maintains its own memorial to the events of 1692. *Photograph by John Goff.*

The Wilmott Redd memorial stands near Redd's Pond in Marblehead. Hanged on Gallows Hill in Salem in 1692, Redd was an innocent victim of the Salem witch hysteria. *Photograph by John Goff.*

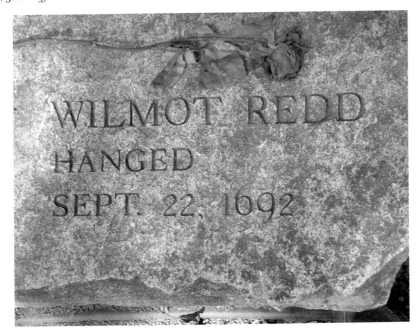

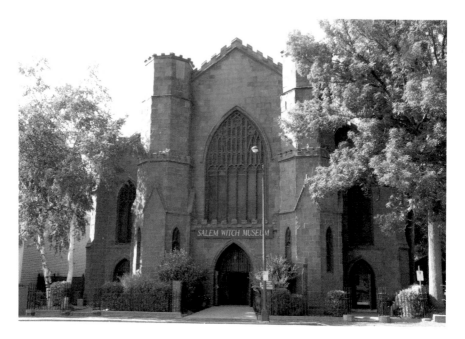

The Salem Witch Museum facing the Salem Common interprets the Salem witch hysteria and trials of 1692. *Photograph by John Goff.*

Reverend Parris, a tempestuous and difficult man, flew into a rage after simply hearing that a "witch's cake" was being proposed. Parris thought that employing such a method would literally raise the devil, and he began to cross-examine the girls to find out what afflicted them. Before long, Abigail and Betty were complaining that they were being invisibly pricked and tormented by Tituba herself. Accusations then were pointed at Sarah Good, a beggar, and Sara Osborne, a "bedridden outcast." With each naming of a new potential suspect, the misery of many others was just beginning. They, too, would be assumed guilty until proven innocent, and many lives and families would be altered and disrupted.

Space limitations here do not allow us to provide a full account of the Salem witch hysteria events of 1692 and 1693. However, over seventeen months, the disruptions that began in the Salem Village parsonage increasingly began to effect more and more families, until rich and influential families were also named, twenty innocents were killed by public hanging and/or pressing and a whirlwind of intense fears, accusations, investigations, jailings and legal actions promised distinctly that life in and around Salem would never be the same.

THE VICTIMS

Twenty innocent people lost their lives directly due to punishments meted out during the Salem witch trials and executions. These were courageous Puritan citizens who were killed because they refused to confess to aiding and abetting the devil, even though at the time the punishment for not confessing was known to be death. Victims included both men and women (but mostly women) who ranged in age from thirty to eighty. A variety of people, including a dissident minister (George Burroughs), lawyer's wife (Bridget Bishop), fisherman's wife (Wilmott Redd) and farmer (John Wilard), were mostly hanged on Salem's Gallows Hill. One victim, Giles Cory, was pressed to death.

A list of all twenty, in alphabetical order, contains the following names: Bridget Bishop, George Burroughs, Martha Carrier, Martha Cory, Giles Cory, Mary Easty, Sarah Good, Elizabeth Howe, George Jacobs, Susannah Martin, Rebecca Nurse, Alice Parker, Mary Parker, Ann Pudeator, John Proctor, Wilmott Redd, Margaret Scott, Samuel Wardwell, Sarah (Averill) Wildes and John Willard.

THE WITCH HOUSE AS A TOUCHSTONE TO SALEM IN 1692

Thousands of tourists each year visit Salem's so-called Witch House at Essex and North Streets attempting to better appreciate what Salem was like in the late seventeenth century. They come primarily to understand what it was like in 1692, a horrible and traumatic year due to the witchcraft hysteria, the trials and the jailings, as well as the multiple hangings on Gallows Hill.

The Witch House is among the most visited of Salem's true relics from the 1692 period because it remains the only known surviving structure with direct ties to the 1692 events. In addition, it is downtown, easily accessible, city owned and mostly restored to a seventeenth-century appearance.

Gallows Hill, arguably more significant, has less now to show the visiting tourist. The site of Salem's 1692 jail has also been totally redeveloped, while the Rebecca Nurse Homestead in Danvers, which has a larger intact seventeenth-century property, is more difficult to access. For all these reasons, the Witch House remains Salem's most visited historic First Period site associated with the 1692 events.

The Salem "Witch Jail" in 1692 held the accused before trial. The timber-frame structure was converted into part of a Victorian house by the 1890s. Number 10 Federal Street, Salem, now occupies the site. *Frank Cousins photo, courtesy Stephen J. Schier.*

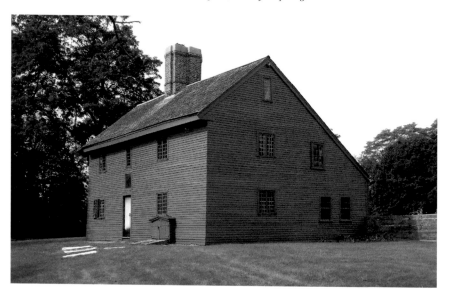

Another quite famous victim of the 1692 witch trials was Rebecca Nurse, who resided in Salem Village (Danvers). The Nurse Homestead is now restored and open to the public. *Photograph by John Goff.*

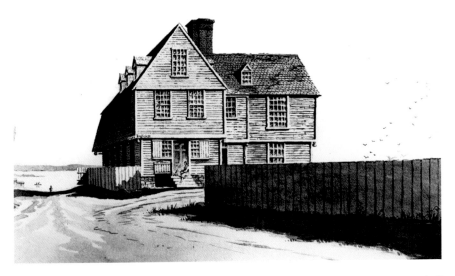

Philip English lived in the English House on English Street in Salem until he was accused of witchcraft in 1692. *Frank Cousins photo of rendering, courtesy Stephen J. Schier.*

It is worth noting that when Samuel A. Drake published the book *Historic Mansions and Highways Around Boston* in 1899 (just seven years after the bicentennial of the Salem witch trials was experienced in 1892), he penned a whole chapter on "The Old Witch House." He explained that it was "much visited by the morbidly curious." In the house, he explained that "family tradition assigns the south-east lower room [or right front room] in Corwin's house as the scene of some of these [1692 preliminary examination] proceedings." Drake also reprinted some of the known dialogue from the examination of Salem accused prisoner Susanna Martin to illustrate how a primitive legal system and a widespread belief in the reality of witchcraft combined to entrap victims and to seriously miscarry justice here in Salem in 1692.

THE WITCH HOUSE AND THE WITCH CITY

Following the initial seventeenth-century periods of hysteria, jailings, hangings and other punishments, people came to realize that all the Salem 1692 persecutions were in error, due to a flawed justice system. During much of the eighteenth century, Salem and Danvers residents lived with shame about the 1692 developments, and the "witch" history was not discussed much.

Yet as the 1892 bicentennial of the Salem witch trials approached in the late nineteenth century, a number of Salem businessmen, following jeweler Daniel Low's example, began to realize that commercial profits could be obtained from marketing Salem as the "Witch City" upon the 200th anniversary of the 1692 events. As interest in Salem's "witch" history increased, a number of new Victorian businesses were established that had "Witch City" in their names, and the ancient house of former Salem witchcraft judge Jonathan Corwin increasingly became identified as the "Witch House."

Since the 1890s, Salem has been known far and wide as the "Witch City." The tragic Salem witch trials and persecutions cruelly stole lives, liberty, fortunes, reputations, peace, health and justice from many individuals and Salem area families in the late seventeenth century. What began as local events in both Salem Village and Salem Town (now Salem) in 1692 quickly affected other areas, as some of Salem's accused fled to far-reaching outlying areas like Framingham, Massachusetts, and distant England to avoid capture.

The 1692 events also quickly became larger than Salem when authorities and accused persons in nearby Boston and connected with the Massachusetts Bay Colony's governing power structure got swept into the turmoil. America's first famous "witch hunt" was characterized by widespread fear and disillusionment, a need to find scapegoats or causes and a systematic process of extracting information of dubious quality. Francis Hill, author of *Hunting for Witches: A Visitor's Guide to the Salem Witch Trials*, explained in 2002 that the hysteria "caused 150 men and women to be thrown in prison and hundreds more lives to be blighted or ruined....The historical witch hunt was a horrific, complicated, fascinating episode, far more absorbing than any fiction [such as Arthur Miller's play *The Crucible*] or myth."

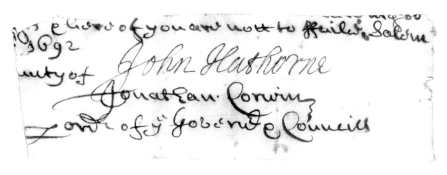

Corwin and Hathorne signatures on witchcraft documents; Jonathan Corwin of the Corwin House and Jonathan Hathorne were two of the best-known "Witch Judges" in the 1692 witch trials. *Courtesy Danvers Archival Center.*

Salem's so-called Witch House will eternally be tied to this dark chapter in Salem's history, as in 1692 it served as the primary house of Jonathan Corwin who, along with John Hathorne (Nathaniel Hawthorne's ancestor), was one of the most famous judges during the trials. The emotional intensity of the 1692 events tends to make people in modern times singularly think of the house and property as a "witch" property, overlooking other associations with Native Americans, the Davenports, aspects of Corwin family life and the site's significance in later chapters of American history.

At least a dozen cities and towns in Massachusetts today can point to cemeteries, memorials and historic sites that in one way or another were directly tied to the Salem witchcraft hysteria of 1692–93. Resources and sites in eleven different eastern Massachusetts communities were identified by Frances Hill in 2002. The Hill-identified communities all occupy a band along or near the Atlantic shore ranging between Boston and Newbury and listed alphabetically as follows: Amesbury, Beverly, Boston, Danvers, Marblehead, Newbury, North Andover, Peabody, Salem, Topsfield and Wenham. West of all these communities, the town of Framingham also has an entire neighborhood, "Salem End," that was settled by people who were fleeing unrighteous persecution (including Rebecca Nurse's sister Sarah Cloyce). No doubt as research continues, additional sites across New England will be found to have historical associations with the lives of families and persons involved with key chapters of the Salem witch hysteria that in turn spun out of control based in part on the findings of Judges Hathorne and Corwin.

CHAPTER 5

COLONIAL KINGDOMS

In the early 1700s, the Witch House was still remembered for its local associations with two intense seventeenth-century colonial tragedies: King Philip's War and the Salem 1692 witch trials and hangings. A sort of old and gray cloud hung over the property. Consequently, as the eighteenth century matured, the Corwin family, who continued to own the property, worked to actively change, brighten, modernize and improve the way their family and house were perceived. We see the younger Corwins providing more public service in Salem, and after 1740, the house was radically reconfigured to support the latest Renaissance-derived English Georgian style.

The eighteenth century came to be a time associated with sophistication, rationalism and urban style. Most New Englanders between the 1720s and 1750s increasingly looked to Mother England to obtain the most up-to-date trappings of transatlantic culture and worldly success. When Salem, Massachusetts, was under English colonial rule prior to the American Revolution, it was literally part of the British Empire. Salem's most prominent and influential leaders looked to the east for education and influence and to create mini-kingdoms of their own on American soil. Wealth generated from the maritime trades created a new "Codfish Aristocracy" in New England and in Salem. Leading local families with the last names of Corwin, Cabot, Crowninshield and Derby adopted British fashion and built anew or rebuilt older houses in the new Georgian style. On Essex Street during this period, many of the most fashionable estates (like the Witch House) were built on the north side of Essex Street to have good sun exposure on their front façades.

Behind the major merchants' and aristocrats' houses, land sloped down to Salem's North River, where wharves and docks allowed ships to dock and tie up, as well as to load and discharge cargoes directly under the watchful eyes of the ship owners.

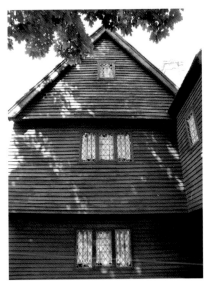

Salem Witch House roof gable and jettied overhangs. *Photograph by John Goff.*

THE BELOVED REVEREND GEORGE AND MEHITABLE CORWIN

In the early eighteenth century, Judge Jonathan Corwin's family worked to perform more positive community service. The witchcraft judge Jonathan Corwin's son, Reverend George Corwin (born in 1682 and a member of Harvard College's class of 1701), entered the ministry. He was remembered for having done much good for Salem's poor before he passed away at only thirty-five years of age in 1717. Reverend George was an influential church leader at Salem's First Church, which then stood near the ancient spring site and where the Daniel Low & Co. building stands now.

Reverend George Corwin was assisted in his theological duties by the Reverend Nicholas Noyes. Reverend George Corwin married the beautiful young Mehitable Parkman (eight years his junior), the daughter of Captain Deliverance Parkman, who resided on Essex Street just east of the Witch House. The young couple appeared to have a very bright and promising future until both died prematurely in 1717–18.

A CORWIN CURSE? THE DEATHS OF 1717–1718

A highly contagious and deadly fever swept through the Witch House and the Corwin family in 1717 and 1718. At this time, Judge Jonathan's son Reverend George Corwin was the principal occupant of the inherited mansion house

with his wife Mehitable. They were also raising three children in the house and were evidently taking care of George's parents. After the fever swept through the First Period landmark, only two young boys were spared their lives: George Corwin Jr. and Samuel Corwin.

Samuel later became famous for his leanings as a Loyalist during the Revolutionary War. Within his journal, edited by Andrew Oliver, he described the grim and ghastly developments of 1717–18, when he was but a small boy:

> *Before the 2nd year of my life* [in 1717] *was completed, it pleased God to take away a kind and tender father* [Reverend George Corwin] *by death, an insupportable loss, a loss I've severely felt in the course of my life, a loss I momently and mournfully reject....Nor was this melancholy visit single and unattended; one great misfortune, 'tis observed rarely comes alone. Before the resolution of one year, Death that unrelenting evening of mankind made such havoc among my relations, having laid in cold...grave* [an additional] *four out of six remains of my family. My grandmother died in July, in August my grandfather, in September my*

Salem's Old Town Hall, at Derby Square, stands on the site of two earlier mansions: one built for the Brownes, and one for the Derbys. Some of the Corwins/Curwens were raised in the Browne House. *Photograph by John Goff.*

then only [other?] *Brother and in beginning of December in less than 13 months from my father's departure followed my mother who lived to her 27th year leaving three children, 2 of which have followed in room of their ancestors. Her death at that time closed the mournful tragedy and left 2 helpless and nearly relationless orphans my said posthumous* [or, rather, then still living] *brother and myself less than 3 years old. We were the only remains of a late very numerous family.*[19]

"[T]he only remains of a late very numerous family" were the horrifying words spoken by Samuel Corwin, a rare eighteenth-century survivor of the 1717–18 pestilence and grandson of Judge Jonathan Corwin. For one of Salem's wealthiest and most respected families to be cut down so quickly, and so thoroughly, leaving just a pair of young boys to be raised as orphans, is certainly one of the most bizarre and tragic chapters in colonial Salem history. For the Corwins as a family, the 1717–18 plague was close to a holocaust, serving to almost wipe the family, and family's name, off the earth. As Samuel so tragically put it: "Death that unrelenting evening of mankind made such havoc among my relations."

Rescuer of the Young Corwins: Colonel Samuel Browne

Prior to the Revolutionary War, a very wealthy Salem merchant named Colonel Samuel Browne lived in town a short distance east of the *shawmut* or ancient water spring at the site now called Town House Square. He maintained a southern-style plantation in Connecticut, and with the proceeds of his many maritime, mercantile and agricultural dealings, he built a large mansion where now stands Salem's Old Town Hall. Here, after about 1717, "in an upper chamber in my guardian's house with children of family about my age" lived Samuel Corwin (and possibly also his brother George) under Colonel Browne's protection.

The only two surviving Corwins—the boys Samuel and George Jr.—were raised by the wealthy Salem Brownes between about 1717 and 1740. During this long period, the ancient Witch House property at Essex and North Streets was placed and kept in guardianship by Colonel Browne for the two minor boys.

1740S GEORGIAN PERIOD DEVELOPMENTS

Between October 27 and November 1, 1740, George and Samuel Corwin, now young men, embarked on a series of meetings and site inspections to amicably divide their grandfather Jonathan Corwin's mansion house homestead property. George Corwin, being the older boy, was granted title to the ancient timber-frame house itself, along with frontage of about 60 feet on Essex Street and about 170 feet on Curwen's Lane that has since been renamed North Street.

Samuel Corwin, the younger boy, was granted title to a large L-shaped parcel to the west of the original site of the Corwin or Witch House. Upon this western parcel, Samuel by the late 1750s built a newer house of his own (since improved and moved to 9 North Street as the Nathaniel Bowditch House, or Bowditch House). Because street takings in the 1940s widened North Street at the expense of George Corwin's old lot, the Witch House, moved to its current site after World War II, now occupies old family land granted to Samuel Corwin, the Loyalist, in 1740.

The eighteenth-century Derby House on Salem's Derby Street near Derby Wharf is a fine example of a Georgian-style mansion. The Witch House was modernized in the eighteenth century to display a large Georgian-style gambrel roof, similar to the Derby House. *Photograph by John Goff.*

The 1730s and 1740s in Salem saw the sweeping into fashion of a new architectural style, called the Georgian style, or English Georgian style. The Georgian style derived its name from the multiple King Georges who sat upon the English throne during the eighteenth century. It was picked up by sea captains and travelers and brought back to New England because it had a rationality, symmetry and magnificence that displayed the arrival of Renaissance thought both overseas and in America. Key characteristics of the new Georgian architectural style included doing away with all the peaked, post-mediaeval roof gables that were such the fashion in the late seventeenth century and introducing both hip roofs (sloped on all four sides, like a pyramid) and long double-pitched barnlike roofs called gambrel roofs.

To update the old Corwin property according to the tastes of the newest Georgian fashions, during the 1740s and 1750s several major changes were made. Changes were made on three buildings, now called the Witch House, Lindall-Gibbs House and Bowditch House.

On the Witch House, the circa 1675 peaked gables and projecting front porch were removed, probably in the 1740s. Also, about 1747, a large new gambrel roof was built on top to adapt to the latest fashion and create a

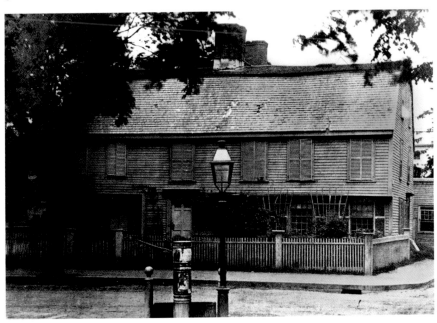

One of the most famous images of the Witch House is this view, taken in 1856. Note the eighteenth-century Georgian-style gambrel roof. *Frank Cousins photo, courtesy Stephen J. Schier.*

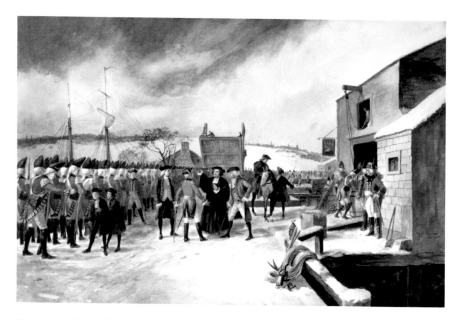

The Salem Witch House was a witness to the Leslie's Retreat affair of 1775, as well as the earliest armed confrontations in the American Revolution. *Lewis J. Bridgman illustration, courtesy Peabody Essex Museum.*

larger house for George and Sarah Corwin's growing family. George and Sarah's daughter Mehitable Corwin (named for George's deceased mother) was by all accounts a brilliant star in the family, even before she married Salem ship captain Richard Ward of the first ship *Astrea*.

West of the Witch House, in 1755, a fine new house was built for Mary Lindall, a cousin of Samuel and George Corwin. Mary Lindall's new house was also built to showcase a fine new Georgian-style gambrel roof above two full floors.

Finally, in 1759–60, between the Lindall-Gibbs House and the Witch House, the Loyalist Samuel Corwin built a new house for himself upon Corwin lands he had inherited. He built a two-story Georgian hip roof mansion. It was later modernized in a Chinese Federal style and raised to three stories about 1800 in the Federal Period by Captain William Ward. Still later it became known as the Bowditch House—named for the family of Nathaniel Bowditch, the famed navigator, who resided there between 1811 and 1823. This house was moved from its original location to a new position north of the Witch House at the time when the Witch House was moved west to accommodate a widening of North Street in the 1940s.

Loyalists, Leslie's Retreat and the Revolutionary War

New England assumed a distinctly British character during the several decades between the 1720s and 1760s as the English Georgian style was increasingly used to renovate older landmarks like the Witch House and also to create fine, fashionable mansions throughout the seaport town. The Georgianization of the older architecture and the large gambrel roof built atop the Witch House in the 1740s can be seen as part of a larger movement at this time by Salem's leading families to adopt the latest British fashions.

Some architectural historians—and archaeologists such as the late Jim Deetz, author of *In Small Things Forgotten*—proposed that the sweeping in of the Cartesian, rational Georgian style in the early to mid-eighteenth century represented nothing short of a major revolution in thought: an acceptance of new Renaissance ideals from Europe that quickly replaced the older, less formal and more organic order. As the older order was swept out and the newer fashions were adopted, changes occurred in many places. For example, older multi-gabled roofs with an abundance of post-mediaeval or Gothic features were typically shorn of their steep-pitched triangular dormer windows and changed to display a gambrel roof, or a hip roof. Dormer windows, where used, were now typically rectangular and not triangular. In similar manner, the older casement windows with out-swinging wood casements fitted with many Gothic-style diamond-shape quarrels or lights were typically cast out in this period to favor the newer double-hung sash window of vertical rectangular proportion with vertical rectangular panes in each sash. Asymmetrical arrangements of windows were rejected in favor of regular, formal, symmetrical façades.[20]

The bold new eighteenth-century fashions for Salem were crystallized in new Georgian-style houses built for members of the Barnard, Cabot and Derby families, as well as others. Leading examples of the new style could be found in a number of new gambrel roof mansions. For example, between about 1727 and 1730, sea captain and fish merchant John Crowninshield built the fine Georgian-style Crowninshield-Bentley House now located at 126 Essex Street opposite the Hawthorne Hotel. Closer to the Witch House, in the late 1720s, merchant Samual Barnard erected the impressive Ropes Mansion at 318 Essex Street, one of Salem's most imposing Georgian- and gambrel-styled new houses. Between about 1744 and 1748, Salem merchant Joseph Cabot built in the new Georgian style the colossal Cabot-Endicott-Low House, now numbered 365 Essex Street, located across from the Salem Public Library.

When the ancient circa 1674 Witch House was drastically modernized to support a large gambrel roof and new windows, etc., in the Georgian style about 1747, the work was done for George and Sarah Corwin to put the Corwins in the same class and league as the Crowninshields, the Barnards and the Cabots. Within a few years, other fine houses would be built in Salem to continue the English Georgian transformations. These included the Lindall-Gibbs House built at 314 Essex Street in 1755 and the superb brick Derby House built by Captain Richard Derby at 168 Derby Street in 1761–62 for his son, Elias Hasket Derby, and his wife Elizabeth Crowninshield Derby.[21]

The strongly pro-British sentiments evidenced by the widespread adoption of the Georgian style and by the import of fancy English trade goods and ceramics during the 1720–60 period would likely have continued for many more decades had not an unfortunate new wrinkle in Anglo-American relations developed in the 1760s: the first political objections associated with the incipient American Revolution. Increasingly anti-British feelings were triggered initially by perceived unfair tax policies and tariffs imposed by King George II and the mother country. In reaction to the Stamp Act and other repressive policies, the Boston Tea Party was staged as a bold act of colonial protest on December 16, 1773.

As relations grew increasingly strained between anti-English and pro-English factions, the houses and properties of wealthy Loyalist families in Salem were physically attacked and, in some cases, taken from the Loyalists. The Ropes Mansion west of the Witch House, for example, was reportedly attacked by a mob during the Revolution. The Browne property east of the old spring site was taken by Patriot or rebel forces and eventually converted into a new town hall and Market Building for the people of Salem. As conditions grew more chaotic in the 1770s, Loyalist Samuel Corwin, who resided next door to the old Jonathan Corwin or Witch House, fled Salem for London with the intention of simply waiting out the conflict.

An abundance of Revolutionary War activity was seen from the windows and property of Salem's old Witch House in the 1770s. Arguably the most significant was Leslie's Retreat. In February 1775, two months before the outbreaks at Concord and Lexington and the "shot heard 'round the world," the first blood was drawn in the Revolution on North Street near the old North Bridge. A standoff between British Regulars and armed locals resulted in one man being pricked by a British soldier's bayonet. The turning back of the British so close to the Witch House dramatically proved that the American colonial forces were organized. They were a force that could sometimes prevail. In addition to its value as an early site associated with a

pre-1626 Native American Indian trail and the 1670s Davenports of King Philip's War, as well as the 1692 Salem witchcraft hysteria, the Witch House site is significant as one that witnessed Leslie's Retreat, an important opening chapter of America's Revolutionary War and march toward independence.

CHAPTER 6

FORGING AN AMERICAN IDENTITY

S alem played some decisively significant roles in the winning of America's War of Independence. In addition to being the place where Leslie's Retreat occurred—the first armed conflict of the Revolution in February 1775—Salem remained an active and unblockaded seaport throughout the war. This permitted it to become a haven for privateers who used American ships to harass and attack British vessels. The Derby family, first discussed in connection with Salem's Georgian architecture, maintained a fleet of ships throughout the war, including one, the *Quero*, that sped news of an American version of the conflicts at Concord and Lexington to British shores before the English army report was read, increasing English support for the Americans. In time, the Derbys leveraged their status as important ship owners into new positions through which they opened up the fabled New England China Trade and helped usher in a Golden Age of Sail, in which Salem ships from exotic Far East ports returned, earning great riches from imports of Chinese tea, porcelain, silver, furniture, silks, spices and other luxury goods.[22]

We tend to think of the Revolutionary War as a simple historical event, a point in time in the 1770s that delivered us American independence. Yet in fact, the Revolutionary War was much more. It radically transformed the way people in Massachusetts, and people in Salem, thought of themselves—it was as much a psychological revolution as a military one. The high ideals of liberty, freedom and national sovereignty ushered in national and civic pride and a larger way of thinking about life on Earth

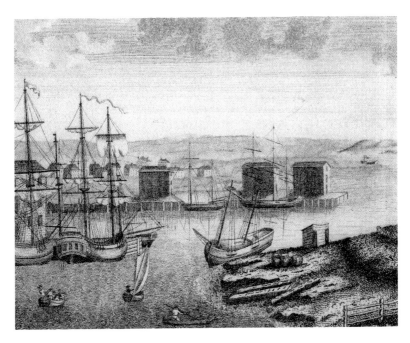

Salem was a prosperous global seaport before the Embargo of 1807. *Salem Marine Society image, courtesy Peabody Essex Museum.*

The Salem Maritime National Historic Site with the ship *Friendship* portrays Salem in the Great Age of Sail. *Photograph by John Goff.*

and the potentials for growth. These in turn transformed the way houses, towns, cities and landscapes were designed and built.

The Revolution was fought largely to preserve and gain American mercantile rights to trade freely with any other people on the planet, rights that were not granted by the British when New England was an English possession. Winning the war secured the ability to trade directly with the Far East and introduced a global outlook and perspective. Here we shall consider how Salemites, the Corwin or Witch House occupants and Salem's architecture were all affected during and after the war by new global and national concerns, changing fashions, a booming maritime economy and Far East imports.

Old photographs surviving in Salem prove conclusively that Salem's ancient Witch House did not stand completely isolated from the great changes in wealth and fashion that swept through Salem between about 1780 and 1830. True, during these years the house did retain its large gambrel roof that was such a hallmark of the older pre–Revolutionary War English Georgian style. However, newer postwar improvements from the later Federal era and Federal style were also built, including a brand-new and delicate Federal-style wooden fence that provided a new air of refinement to the Essex Street sidewalk. In addition, a new Federal-style carriage house with a large arched opening showing Samuel's influence was built just west of the Witch House. Yet neither the Federal-style fence nor the Federal-style carriage house survive today.

But what was this newer Federal style, and what was the Federal era? To appreciate the flavor and fervor of these times, we need to consider how much energy was invested after the Revolutionary War seeking to *forge a new American identity*.

The Revolutionary War left Americans victorious but in debt and with sharp anti-English feelings. After all, victory and national independence had been purchased at high cost—both in terms of lives and national treasures lost. Independence and the process of becoming a new nation also required the new United States to develop many new things that the colonies did not have before, including a new central government, a new national currency, national banking system, new national transportation and defense systems and so on. The term "Federal" came to be applied to the architecture and developments of the postwar era largely because these decades were focused on infrastructural improvements at new national or federal scale.

Reacting against the older English Georgian architecture and prewar Anglophilic sentiments, architects and homeowners wanted to design and

build wholly anew during the newer Federal period—and in a new, uniquely American style. In their desire to acquire a new American identity, they bitterly rejected anything and everything associated with the English. Rejecting the older English Georgian style, Federal-era designers like Samuel McIntire of Salem, Charles Bulfinch and Asher Benjamin of Boston and Thomas Jefferson in Virginia instead chose to design and build anew using pattern books produced by the Scottish designers Robert and James Adam. As a consequence, the newer Federal or Federalist style architecture has also been called "Adamesque." Pattern books published in the United States made the new style(s) readily accessible to builders in most major port cities.

The newer Federal or Adamesque buildings were often designed in substantial brick and granite, with delicate carvings and details designed to "read" strongly against simple, flat cubic masses and/or planar fronts. Federal-style buildings were often decorated with multiple chimneys, hip roofs and superior wood carvings showing swags, wreaths, urns and more derived from study of classical ruins. Elliptical fanlights and ornate porticos and balustrades were also added to become elegant highlights. Wrought-iron bootscrapers on granite steps and granite pavers out to the street edge were additional typical details in front of the Federal-style home, while adjacent or behind the house was often situated a fashionable Federal-style carriage house, sometimes with a large arched openings in its design. Ornate fences with fancy wood "sticks" and large pilastered or encased posts supporting carved urns or round balls were additional character-defining features of the latest Federal style. Patriotic motifs such as carved American eagles, bas-relief carvings of George Washington or sheafs of wheat (symbolizing America's richness) also became widely popularized in these years.

With great new wealth, abundant white pine and New England timber, skilled housewrights and architects like Samuel McIntire familiar with the delicate hallmarks of the latest Federal or Adamesque style ushered in vast urban changes in places like Salem, Boston and Newburyport, Massachusetts. A surprising assortment

The Salem Witch House at Essex and North Streets stands at the main gateway to the McIntire Historic District, named for Samuel McIntire. McIntire motifs of wheat mark the McIntire Trail in the district. *Photograph by John Goff.*

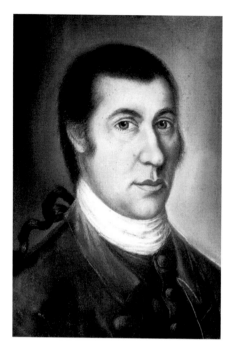

Salem woodcarver and architect Samuel McIntire designed Federal-style buildings in Salem after the American Revolution. *Courtesy Peabody Essex Museum.*

of superb new Federal landmarks was designed and built in Salem. Hundreds of new Federal-style houses, commercial buildings, churches, wharves, ropewalks, etc., were built in the Federal period. Salem today is considered to be the best-preserved Federal-era seaport in the entire United States.

Maritime commerce exploded in all directions during this period, ushering in unparalleled new prosperity and a global outlook in Salem. Local leaders who benefitted most from the new conditions included Elias Hasket Derby and Samuel McIntire. Salem's Elias Hasket Derby, reportedly America's first millionaire, was the merchant and ship owner who opened the fabled China trade for all of New England.

The Derbys and other Salem merchants like the Crowninshields, Silsbees, Grays and Wards held a unique advantage in that the port of Salem was never blockaded by the British during the war—though it was the scene of much American privateering—and possessed skilled navigators and fleets of ships at war's conclusion. Soon after peace was establish with the Treaty of 1783, Salem merchants were off and running to grab an American share of the lucrative Far East trade.

The Far East and China trades generated great fortunes for Salem ship owners, sailors and merchants, rewarding those who braved the hazards of storm, piracy and shipwreck and who put their lives on the line to advance their families and hometown. Imports of exotic Chinese and Asian porcelains, silver, furniture, silks, fans, ivory and other luxury items such as pepper and spices helped Salem earn vast riches, as well as a command of trade in exotic ports. As evidence of the great wealth generated during these times, Salem even today retains two large red brick Federal-era customs houses (one on Central Street and one on Derby Street) that were used to levy taxes for the federal government on the fortunes made in the maritime trade.

FORTUNES FUNNELED INTO ARCHITECTURE

As Salem sea captains and citizens sailed the globe, saw distant ports and acquired great imports of exotic luxury goods from overseas, new desires grew to transform Salem into a more modern and progressive town. Wealth earned from the maritime trades in particular opened up new possibilities of building Salem anew. But precisely how should they build?

Samuel McIntire, now famed as Salem's brilliant woodcarver and architect of the Federal period, played a dominant role in helping to reshape Salem during this era. The McIntires were of Scottish ancestry who had first come to Massachusetts in the seventeenth century as indentured laborers at the Saugus Iron Works, south of Salem. By the eighteenth century, they had earned their freedom and started to excel in the building trades. Samuel McIntire's father Joseph, in particular, earned a good reputation as a Salem housewright in the English Georgian period of the 1750s and was significantly involved in 1759 working to build parts of a new hip-roofed Georgian-style house for Samuel Corwin (the Bowditch House), which stood on the Witch House site until the 1940s. The 1750s Samuel Corwin House was later converted into a three-story house, with a new Chinese-style balustrade, likely by Joseph's son Samuel McIntire, working for Captain William Ward, about the year 1800. The Wards emerged as one of Salem's most well-to-do maritime families during the Federal period. Captain William Ward derived much of his wealth by following William "Billy" Gray to sea and to Far East ports. Gray was heralded as one of New England's wealthiest ship owners. He owned interests in over 150 ships, as well as cotton duck (canvas) manufacturing facilities in Saugus, Massachusetts, ropewalks and other industrial facilities.

Samuel McIntire (1757–1811) obtained many architectural and woodcarving commissions between the 1780s and 1811 in Salem that invited the use of Chinese architectural elements to celebrate Salem's ties to the Far East. In addition to the Corwin-Ward-Bowditch House (now moved to nearby 9 North Street, north of the Witch House), whose original Chinese balustrade is attributed to Samuel McIntire, other structures like the Gardner-Pingree House on Federal Street and the Derby-Beebe Summer House (owned by the Peabody Essex Museum) are good examples of Samuel McIntire work in Salem showing Chinese influence. Samuel McIntire was also engaged to carve a large wooden figure of a Chinese man in traditional costume and to build many large mansions for members of the Derby family, related to Elias Hasket Derby, who pioneered Salem's China trade.[23]

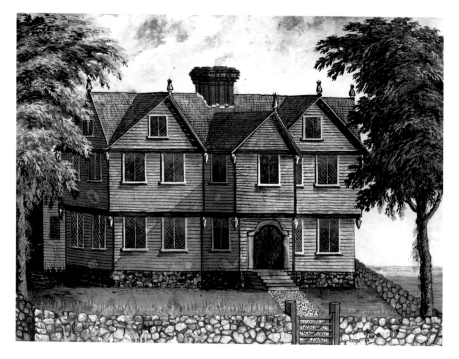

Samuel Bartol produced one of the earliest conjectural restoration images of the Witch House at a time when it had an eighteenth-century Georgian-style gambrel roof. *Frank Cousins image, courtesy Stephen J. Schier.*

Two of Samuel McIntire's finest Salem landmarks surviving from the early nineteenth century include the Gardner Pingree House, now owned by the Peabody Essex Museum, and Hamilton Hall, located a few blocks south and west of the Witch House. The Gardner-Pingree House in downtown Salem remains one of McIntire's finest mansions from circa 1805. On the Essex and North Street corner, the Wards and Corwin heirs showed their familiarity with the newest styles by modernizing the Corwin-Ward-Bowditch House (Bowditch House) in the new Federal style (with Chinese balustrade) circa 1800 as described above and by adding a new Federal-style fence and Federal-style carriage house near the ancient Corwin or Witch House.

Two of the more noteworthy improvements that were developed in Salem during the Federal period were a series of flat-roofed, or hip-roofed, carriage houses with wood doors set into arched openings and a series of new delicate Federal-style fences that utilized attenuated and slender vertical members to achieve an almost transparent effect. By about 1820, the Witch House acquired new Federal-style improvements of both sorts. A new McIntiresque

carriage house was built near its west side, and a new, decorative Federal-style fence was built to make the property more "up to date" on Essex Street. These improvements helped harmonize the older seventeenth- and eighteenth-century Witch House with the newer and more recently Federalized Samuel Corwin or Bowditch House that then stood just west of the Witch House.

FEDERAL-ERA ARTWORK

In addition to acquiring new fences, and a new Federal-style carriage house as a neighbor, the Witch House during the Federal era also acquired its first conjectural restoration artwork, prepared to show how it looked when first built. This artwork, produced by Samuel Bartol (1765–1835), a student of the celebrated Italian painter Michel Felice Corné, was, like Corné, a product of Salem's booming overseas trade in the Federal period and demand for a new urban sophistication. Corné (born circa 1752) came to New England to flee the Napoleonic Wars, working first in Salem. Finding employment in Salem painting murals, furniture, portraits and views, Corné also provided some Salem students like Mr. Bartol with fine art lessons and trained aspiring artists in the fine points of rendering, composition, color, perspective, shades and shadows. Conjectural "restoration" views of old colonial landmarks like the Witch House were likely also first produced during the Federal era because pictures of ancient homesteads provided a sense of stability in rapidly changing times, while a framed portrait of an old venerated homestead (like a ship's portrait) could connote status in status-conscious times.

Bartol's Views of the Witch House and the Downing-Bradstreet House

With their new Federal-era wealth, Salem and Massachusetts residents hired visual artists like Corné and Bartol to produce new works of art memorializing key developments in the settling of New England. Both artists were hired to produce new views of the landing of the Pilgrims in 1620, yet colonial scholarship was then in its infancy, and many views were shaped as much by romance and conjecture as by fact.[24]

In 1819, Bartol, at age fifty-four, was engaged to prepare reconstructive conjectural views of "restored" lost or altered colonial mansions in First Period Salem. Not long after the War of 1812 concluded in 1815, Bartol prepared a painting or drawing of the historic seventeenth-century

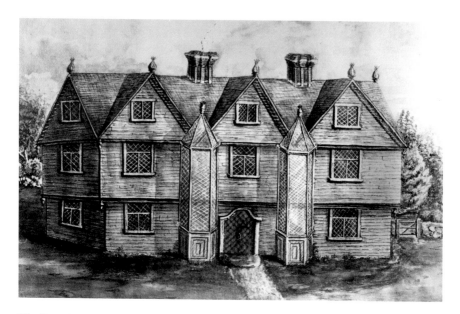

The Downing-Bradstreet House, which formerly occupied a site near Salem's Armory Park, likely looked much like the Davenport-Corwin or Witch House when first constructed. *Frank Cousins image of Bartol painting, courtesy Stephen J. Schier*

Downing-Bradstreet House, which anciently stood near the modern site of Salem's Armory Park. Because this landmark had been demolished over fifty years earlier in 1758, Bartol worked from unknown sources to depict a colossal three-bay, two-and-a-half-story timber-framed Downing-Bradsteet Mansion that had three front-facing attic gables, two side-facing attic gables (five gables total), a pair of brick chimneys and a pair of tall, missile-like engaged stair towers flanking the front door of the house. At about the same time, Bartol produced a similar rendering of the ancient Corwin or Witch House. In 1979, Abbott Lowell Cummings, the authority on Massachusetts Bay Colony First Period houses, called both of Bartol's 1819 architectural views "somewhat questionable" with regards to their working assumptions and their accuracy.[25]

Bartol's 1819 painting of the Witch House, at first glance, appears to have been copied from or strongly influenced by his 1819 painting of the Downing-Bradstreet House. The three-fourths-view presentation angle is alike; the massing of the Corwin House is presented similarly; and eaves overhangs are comparable, as are chimney depictions and rooftop finials. In both views, the wood-frame house is shown adjacent to a rather clunky stone wall, broken by a wood-rail gate with a diagonal brace.

Bartol's Witch House painting likely depicts a semimythical version of a Corwin or Witch House that never actually existed in Salem. For example, by the time the windows were changed to the number of openings indicated, the steep-pitched roof on the real house was likely replaced by the newer gambrel roof. However, in most respects (with the exception of the number of window openings), the rendering was likely quite accurate. The painting clearly demonstrates renewed appreciation of the Witch House as a Salem landmark. The romanticized need or desire to recapture an older appearance evidences much the same desire to build from and continue earlier traditions and to get in touch with old, core colonial American values that later evolved into the Colonial Revival.

Bartol's painting after 1820 motivated later Salem preservationists in the nineteenth and twentieth centuries to restore the house to a seventeenth-century colonial style. In part this was because the existence of the image appeared to provide evidence of many exotic and almost mediaeval First Period picturesque details (like the steep roof, jettied overhangs and rooftop finials) that had been lost through the years. With care, the Bartol painting could be used as a reconstruction and restoration guide. Bartol's painting appears to have further guided Walter H. Kilham's restoration rendering of the Witch House and Essex Street streetscape that was prepared over one hundred years later in the early 1930s. Yet after planting the first seeds that would inform a later twentieth-century restoration of the Witch House, artist Samuel Bartol died in Salem in 1835, some sixteen years after completing his Witch House painting.

POST–FEDERAL ERA CHANGES

The Coming of the Railroad and the Industrialization of Salem

Although Salem as a Federal-era seaport, and Salem's Far East maritime trade, flourished between the 1780s and early 1800s, the maritime trade fell into decline after about 1807, and by the mid-nineteenth century we see Salem redefining itself as an industrial American city rather than an eastern-oriented seaport. A number of factors were responsible for this shift, including, initially, President Thomas Jefferson's Embargo of 1807, which shut down all deep-sea maritime commerce, derailing the old economy.

Two additional elements that worked to hinder the recovery of Salem's status as a seaport included the War of 1812 and the development of newer

technologies (steam power and steamships) that required new ships to favor East Coast harbors with deeper waters than old Salem had available. Steam packet service, which evolved to regularly link England and Europe with the East Coast United States, logically chose New York and Boston to be major terminus points, rather than salty old sea-faring Salem.

By the 1830s and 1840s, America's famed Federal period had passed. Salem's Great Age of Sail also largely ceased to be. Nathaniel Hawthorne, Salem's great writer, complained of the old wharves falling into decay. During these decades, Salem transformed quite significantly from a salty prosperous seaport town that looked primarily toward the East into a growing new modern American city that looked away from the waterfront completely.

Steam power not only introduced new transatlantic packets but also came to revolutionize the way Americans moved across the land. Ashore, investors installed new railroad lines connecting Salem with Boston, and from Boston to Albany, New York, and other western towns. As a consequence, Salem gained many more connections to the south and to the west.

Forward-looking industrialists also harnessed steam power to create the new Naumkeag Steam Cotton Company—a major textile manufacturing facility on Salem's waterfront. As a new railroad depot, textile factories, leather tanneries and machine shops developed in Salem, the city became a new nineteenth-century retail, manufacturing and commercial center.

Salem's ancient Witch House was radically changed in the 1850s after centuries of being owned by the maritime Corwins and Wards and used primarily as a substantial Salem residence. In 1856, Sarah Ward Cushing, the last Ward owner, sold the old family property to druggist George Pickman Farrington. Born in 1769, Sarah had been the last Witch House owner to have deep roots in the older maritime Salem.

DRUGGIST GEORGE PICKMAN FARRINGTON

As Salem redefined itself as a new railroad, industrial and retail center, the focal points of commerce generally shifted from the river and harbor shorelines to places near the new Salem Depot railroad station, on Washington Street, downhill from Town House Square. Steam engines pulling daily into Salem from Boston discharged new crowds of businessmen and shoppers, who looked for hotels and retail establishments nearby. The development of new retail zones and commercial markets sparked some to look at Salem's ancient Witch House in a whole new light.

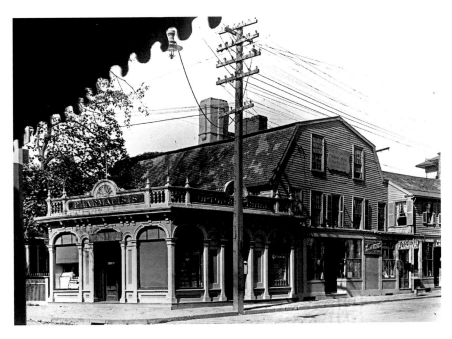

Circa 1890 view of Witch House from Essex Street. *Courtesy Peabody Essex Museum.*

Five years before the outbreak of the Civil War, druggist George Pickman Farrington purchased the Witch House for $3,500. Farrington was an ambitious and enterprising Salem apothecary and businessman. He bought it for its central downtown Salem location and for the high volume of traffic that would pass by the house and the Essex and North Street intersection going to the new railroad station, as well as to North Salem via North Street and Peabody and Boston via Highland Avenue.

Soon after purchasing the Witch House, Farrington constructed a new wood-framed drugstore attached to the front of the house to use as a new business establishment. A flat-roofed, square, one-story addition was designed and constructed in the most up-to-date Italianate style. The Italianate style swept into national popularity mostly in the 1850s decade, in part as a consequence of middle- and upper-class American travelers in the Gilded Age sailing over to Europe and being impressed with large Italian palazzos and landmarks near the Mediterranean. The new Italianate style in the United States encouraged the use of paired, round-top windows, cupolas, broad projecting cornices supported by ornate brackets, balconies, piazzas and larger two-over-two windows, made possible by the larger panes of sheet glass that were now available.

Farrington likely engaged Salem architect Enoch Fuller to design the new wooden front. Fuller was Salem's leading architect and designer in the cosmopolitan new Italianate style, and the bracketed and arcaded front of the new drugstore bore some resemblance to Fuller's Now and Then Club building, which formerly stood close to the Salem Common. Enoch Fuller was quite well known around Salem in the 1850s for his fine work on other Salem Italianate-style landmarks, including the Downing Block at 175 Essex Street, the Classical and High School Building (now COA Building) at 5 Broad Street and the 1850s Plummer Hall by Armory Park, now a part of the Phillips Library of the Peabody Essex Museum. Enoch Fuller, although a native and architectural prodigy of Salem, also worked with architect Calvin Ryder, and they maintained a professional office in Boston. His family homes were located mostly on South Pine Street in what is now Salem's McIntire Historic District—so it would have been exceedingly easy for Fuller to pass the Witch House daily on his walks and rides between South Pine Street and the Salem train station on his trips between Salem and Boston.[26]

THE WITCH HOUSE DRUGSTORE
AFTER THE CIVIL WAR

Not long after Farrington built his new Witch House drugstore addition in the 1850s, America became involved in the brutal Civil War. Between 1861 and 1865, this prolonged military conflict took a terrible toll on thousands of families. Yet precisely during the Civil War years, the new science of photography evolved as an affordable past-time, following the documentary works of Matthew Brady and others. Photography increasingly appeared as a new art form able to record detailed existing conditions in the American landscape. Enterprising artists also began to exploit the new medium to derive new sources of income after the war, especially during the so-called Reconstruction years of the 1870s.

The earliest-known dated photographs of Salem's Witch House survive from about 1872 and 1876. They accurately record how the Witch House then was an odd architectural amalgam of a First Period seventeenth-century house (with central chimney and jettied overhangs), to which a later eighteenth-century Georgian-style gambrel roof had been added—and, even later, a mid-nineteenth century Italianate-style drugstore addition. The 1870s photographs also provide an abundance of information about how Mr. Farrington's drugstore was built.

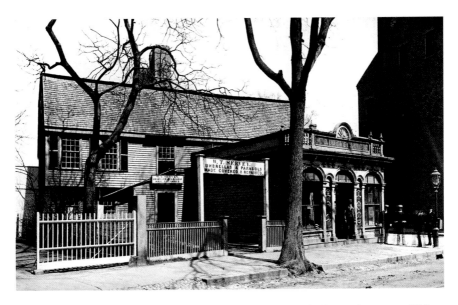

By the 1870s, the Witch House had been altered to include an Italianate drugstore addition and commercial quarters for an English couple who repaired umbrellas. *Courtesy Peabody Essex Museum.*

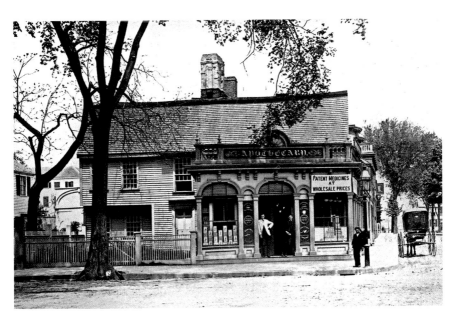

The Witch House became commercialized in the late nineteenth century, which detracted from its historic character. *Courtesy Peabody Essex Museum.*

 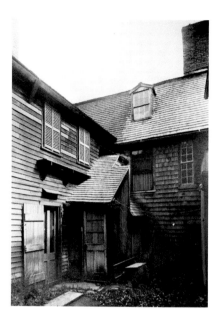

Above, left: The noted Salem photographer Frank Cousins recorded this Victorian-era view of the Witch House. *Frank Cousins image, courtesy Stephen J. Schier.*

Above, right: Before its 1940s restoration, the Witch House on its north side had an odd and picturesque assortment of additions. *Frank Cousins image, courtesy Stephen J. Schier.*

Below: This image dating from circa 1905 was distributed nationally and an early caption for it claimed that it showed "Rear of Witch House…Built 1634." *Postcard image from John Goff collection.*

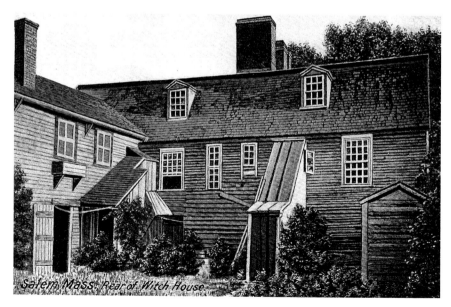

After 1850, we see the Witch House was increasingly used as a place of business to support new commercial uses rather than residential uses. For example, the 1870s photographs also indicate that after the Civil War, an English-born couple, Mr. and Mrs. William T. and Mary B. Severy, occupied part of the house. They used it as a place to offer "Umbrellas & Parasols made covered & repaired." One significant disadvantage of the new commercial uses was that they were typically accompanied by a great increase in product signage, which served only to compromise the historic character of the property and effectively weaken or lose old links with the past. Intensified commercial reuses sparked new concerns about historic preservation that ultimately led to growing awareness that the most appropriate house reuse was to be totally preserved and restored as a historic landmark.[27]

THE COLONIAL REVIVAL
COMES OF AGE

The 1870s brought something else very valuable to Salem and Massachusetts besides the U.S. centennial and renewed local appreciation (proved by the photographers) for Victorian drugstores. In Boston in 1876, one of the state's most cherished historical landmarks—the Old South Meeting House—became threatened with demolition. A group of modern Boston businessmen wanted to tear down the old landmark, at which 1770s Patriots following John Hancock's and Sam Adams's lead had assembled to stage the Boston Tea Party. They wanted the old landmark gone so that a new, up-to-date commercial business block could be built. The cherished Old South, a priceless cradle of American liberties, was at risk of being lost forever.[28]

A noteworthy Boston lady—Mrs. Mary Hemenway (1820–1894), widow of Salem native Augustus Hemenway, saved the Old South. Reported to be Boston's wealthiest lady and driven by a pronounced social consciousness, Mrs. Hemenway in 1876 volunteered the first $100,000 required to save the meetinghouse and challenged her Boston Brahmin friends and associates to come up with all the rest of the needed preservation funds. In 1876, $100,000 was equivalent to at least $1 million in modern currency. The vast Hemenway fortunes were initially generated from maritime adventures: Augustus had opened up American trade with Chile in South America.

At a time when women had not yet secured the right to vote—and women's lib was still a century away—Mrs. Mary Hemenway succeeded in organizing Boston's women to be leaders for heritage preservation. In

Mary P. Tileston
(Mrs. Augustus Hemenway)

Mrs. Mary P. Tileston Hemenway was a highly influential preservationist who saved the Old South Meeting House in Boston from destruction in 1876. *Courtesy Peabody Essex Museum.*

The Old South Meeting House in Boston was saved and reused in 1876 as a new center of American history education. Its preservation saved a landmark and helped put the new Colonial Revival style on solid footing. *Courtesy Old South Meeting House.*

the process, she advanced the political power of women across the state and also helped spark new public awareness and appreciation of both historic preservation and the Colonial Revival. In addition to funding the saving of Boston's Old South, she sponsored programs to have that landmark become a center of American history education and Native American archaeological expeditions in the American West. Mrs. Mary Hemenway personified the diverse interests of the budding historic preservation field and was at least a century ahead of her time.[29]

The roots of the Colonial Revival can be found in the early nineteenth century when artists such as Samuel Bartol began making studies and restoration renderings of America's ancient landmarks. The Colonial Revival movement got a later boost in the 1850s when the Mount Vernon Ladies Association rallied to save President George Washington's Mount Vernon estate before the Civil War. Yet it fully matured in the 1870s and 1880s when interest increased dramatically in American colonial and First Period history. Exploding interests in colonial history and preservation sparked the formation of many new historical societies, the publication of hundreds of new books and undertaking of new historic landmark restorations.

As American history and Colonial Revival interests deepened and broadened in the nineteenth and twentieth centuries, advances were made in many related fields. Genealogical

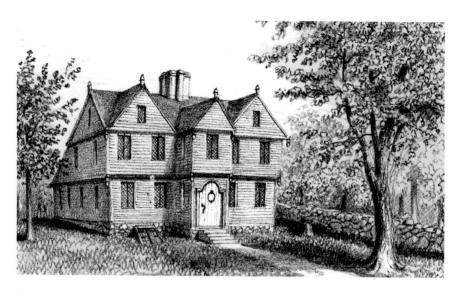

A fine tinted rendering of the Witch House was produced in the 1880s by Edwin Whitefield (1816–1892). *Courtesy Danvers Archival Center.*

societies were created to archive historical collections and to help people track their own family connections to the past. One of the most noteworthy was the New England Historic Genealogical Society, also known as NEHGS, founded in Boston in 1845. The mission of NEHGS is to "Collect, preserve, and interpret materials to document and make accessible the histories of families in America."[30]

New preservation organizations were also formed, like the Society for the Preservation of New England Antiquities (SPNEA) in Boston, recently renamed Historic New England. Patterned after the Society for the Preservation of Ancient Buildings (SPAB) in England, SPNEA, following William Sumner Appleton's lead, began working circa 1910 to preserve and restore many First Period seventeenth-century landmarks across New England, most of which were timber-framed houses like Salem's Witch House.[31]

In addition to new historical, genealogical and preservation societies, the Colonial Revival also motivated many people, especially in New England, to begin to collect, restore and sell antiques and provide period-appropriate furnishings for historic homes. In addition, it inspired American architects, beginning mostly in Boston, to begin to envision new ways in which new buildings might be designed to complement older historic landmarks—and optimal ways in which ancient landmarks should be restored. America's oldest

architecture school was the Massachusetts Institute of Technology (MIT), originally established in Boston. By 1900, MIT developed a field school in Salem so that Colonial Revival architects in training could come to Salem to more closely study the design concepts and landmarks of Salem's Samuel McIntire and details and design features of Salem's oldest structures. The ancient Witch House at the corner of Essex and North Streets in Salem's McIntire Historic District would prove to be the beneficiary of most, if not all, of these Colonial Revival interests.

COLONIAL REVIVAL "RESTORATION" DRAWINGS

As the Colonial Revival and the American centennial excited Americans to want to learn more about ancient sites and early American history, it became natural for people with artistic talents to begin to produce new images of historic landmarks in situ and conjectural images of historic landmarks showing how they likely first appeared in colonial times. If the landmarks were indeed touchstones and windows providing access to significant early eras, new studies and drawings were needed to show how cherished buildings looked when new and how they were used at pivotal or formative early periods in American history.

In the case of Salem's Witch House, Samuel Bartol produced one of the earliest such images in the 1810s. Between 1876 and 1900s, one of the most influential perspective artists was the Englishman Edwin Whitefield (1816–1892). He published several illustrated books on colonial homes in New England. One of his best, *The Homes of Our Forefathers in Massachusetts*, was printed in 1892 and contained a nice image of Salem's Witch House. The year 1892 proved to be especially good for celebrating historic landmarks in Salem, because it marked both the 400th anniversary of Columbus "Discovering" America in 1492 and the bicentennial of the Salem witch trials of 1692.[32]

About 1885, an unidentified Colonial Revival artist in Salem also redrew the ancient Bartol image of the Witch House for publication in a new *Souvenir of Salem, Massachusetts*. However, in the newer drawings, many details were changed. For example, North Street was replaced in the new image by grass and lawn. The front door was given a more curved shape at the top. There were also artistic changes made to the house finials, siding and gate.

Perspective drawings produced by Whitefield and others clearly demonstrated increasing local interest in knowing how the Witch House

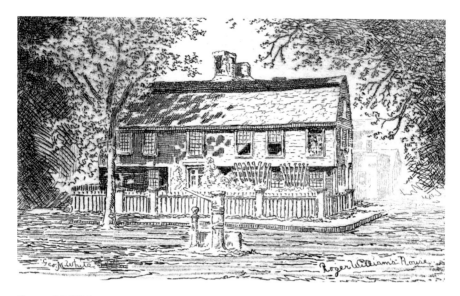

George M. White rendered this view of the Witch House (which he called the Roger Williams House) in the late nineteenth century. *Courtesy Danvers Archival Center.*

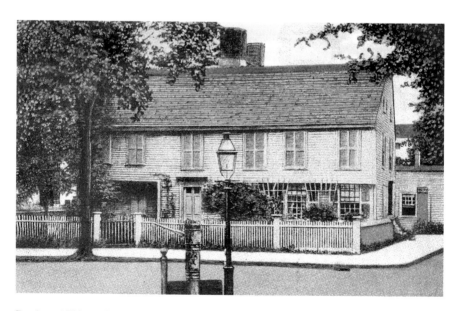

By about 1900, conjectural renderings were made to show how the Witch House would look shorn of its Italianate drugstore addition. *Postcard image from John Goff collection.*

looked when new. The production of new images of this sort planted seeds for new efforts in the twentieth century to remove the 1850s drugstore addition so that the original seventeenth-century appearance of the house could be better seen.

ANTIQUE SHOP IN THE WITCH HOUSE

As Colonial Revival increased in popularity in the late nineteenth century, a few significant changes were made to the Witch House. To begin with, the W.T. Servey "umbrellas and parasols" advertising arch from the 1870s was removed from its old position over the gate leading to the front door of the house. This reduced the commercial appearance of the place and made the property seem more ancient, peaceful and historical. In addition, after Mrs. Mary Servey died in 1899, William T. Servey appears to have sold the main house to James S. Casey, an antique and junk dealer. He ran an ad in the *Salem City Directory* of 1901–2 advertising "Antique Furniture, Historic Ware and Colonial Goods" at "310-1/2 Essex Street…[the] Witch House." The

The Witch House as seen in 1901. *Courtesy Library of Congress.*

new antique shop in the Witch House added to the mystery of the place and gave it a productive new use in the Colonial Revival era, when residents and tourists alike were seeking "Colonial Goods" to furnish both old and new houses in colonial and Colonial Revival styles.[33]

THE ROGER WILLIAMS HOUSE EXCITEMENT AND ERROR

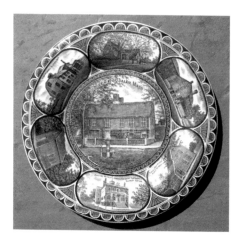

For a time, the Witch House was believed to be Salem's oldest surviving house, as well as the seventeenth-century residence of Roger Williams. Victorian-era souvenirs included blue and white china plates manufactured in England. *Photograph by John Goff.*

Surprisingly, by 1900, new efforts were also taken to popularize Salem's Witch House as the seventeenth-century residence of Roger Williams, the great Puritan minister who founded Rhode Island. Ultimately, the association between Roger Williams and the Witch House was disproved. Yet the confusion appears to have come about for several reasons, including super-charged excitement about unexplored bits of early American history (sparked by the Colonial Revival) and fatigue with Salem being remembered primarily for the tragedies of 1692. After some deeds research revealed that "Mr. Williams" owned land near the Witch House at an early date, one historian proposed such to be proof that Roger Williams had lived in the house. In the early twentieth century, the error was recognized and discussed by Sidney Perley, who found that while Williams had resided in Salem in the 1630s, he lived much closer to the old spring and church site now occupied by the Daniel Low building. Before the error was discovered, many turn-of-the-century postcards and souvenirs were produced advertising the Witch House as the "Roger Willams House." A large colonial-style sign was also mounted on the east gable of the Witch House proclaiming the house to be "ROGER WILLIAMS HOUSE OR WITCH HOUSE" and "Ye Oldest House in Salem...Erected before 1635." For a while, this sign remained in place, but the words were painted out after the facts were proved to be false.[34]

The Colonial Revival Comes of Age

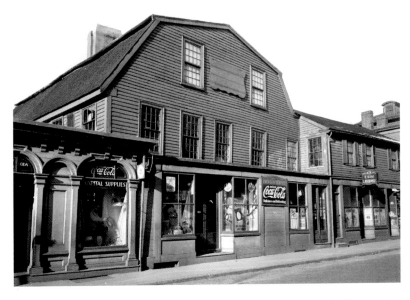

This 1940 photograph by Frank Branzetti shows how densely developed the Essex and North Street corner was before it was mostly cleared at the time North Street was widened. Here the Witch House has its drugstore addition, a large Georgian-style gambrel roof and a Colonial Revival sign (painted out) that claimed the house was the Roger Williams House and "the Oldest House in Salem." *Courtesy Library of Congress.*

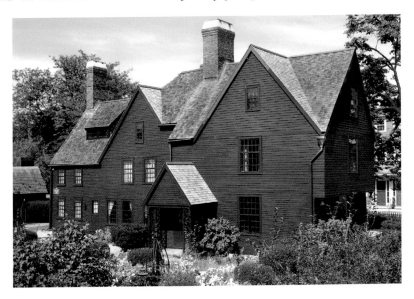

Salem's most famous seventeenth-century residence, the House of the Seven Gables, was first constructed to be one room deep, two and a half stories tall and south-facing, much like the Witch House. *Courtesy the House of the Seven Gables Settlement Association.*

NEW COLONIAL SALEM EXCITEMENTS AND GROWING TOURISM IN THE EARLY 1900S

In the opening decades of the twentieth century, tourism increasingly became a contributor to Salem's prosperity, because increased publications about Salem's history and promotion of Salem as "New England's Treasure House" stimulated new public interests in the place. Furthermore, by 1910, Miss Caroline Emmerton, following Mary Hemenway's example, succeeded in restoring the Turner-Ingersoll House or the House of Seven Gables on Salem's Turner Street to become a major new historic house museum and Colonial Revival attraction. Although both the railroad and trolleys provided abundant transportation and touring opportunities to the public in the 1900s and 1910s, by the 1920s and 1930s new highway improvements and construction of Salem's Hawthorne Hotel further underscored the economic value that might be achieved from marketing Salem as a historic site to new motorists arriving by car.

The 1920s and 1930s were two of the most exciting, educational and transformative decades in Salem, years when people slowed down from the quick-paced modern life of the early twentieth century and began to deeply appreciate their slower-paced, early, simple and colonial roots here in Salem. The Colonial Revival had sparked interest in the anniversaries of the founding of Salem and other North Shore communities. The 1920s kicked off a series of 300th anniversary commemorative celebrations that served as preludes to the 1930 Massachusetts tercentenary.

George Francis Dow advanced the Colonial Revival style in Salem. *Courtesy Peabody Essex Museum.*

Three important tercentenary dates were observed: 1920 marked the 300th anniversary of the *Mayflower* Pilgrims landing at Plymouth; 1923 marked the 300th anniversary of Cape Ann's first English settlement by Thomas Gardner and the Dorchester Company in 1623; and 1926, just

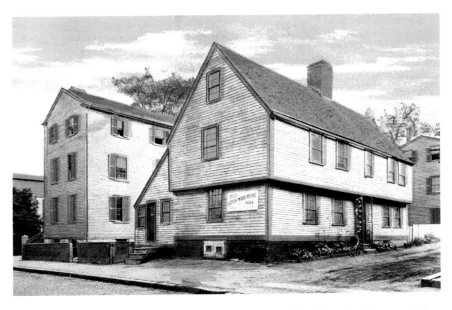

About 1909, George Francis Dow restored the 1680s John Ward House in Salem, and this served as a restoration prototype for the later Witch House restoration. *Antique postcard from John Goff collection.*

three years later, marked the 300th anniversary or tercentenary of Roger Conant bringing the 1623 Cape Ann colony south to Naumkeag in 1626. To properly recognize the Salem tercentenary of 1926 and utilize it to upgrade Salem's ability to sponsor civic and community events, a new Salem Tercentenary Bandstand was conceived, designed and constructed on Salem's Common. The Tercentenary Bandstand was designed by Philip Horton Smith, a Salem-born and Harvard-educated Colonial Revival architect who also designed Salem's Colonial Revival–style Tabernacle Church, the Pequot House, the 1930s restoration of Old Town Hall and the Salem Post Office.[35]

By 1929, larger attentions were focused on the possibility of 1930 holding even more transformative economic and educational value because it marked the Massachusetts Bay Colony tercentenary. The state formed a new Massachusetts Bay Tercentenary Commission (MBTC), whose aim was to improve public understanding of First Period early American history. The commission undertook a variety of new educational initiatives. Some involved highway markers, school programs and a grand 1930 pageant with *Arbella* landing reenactments. Regarding highway markers, a great number of new 1630–1930 Massachusetts 300th anniversary historic site markers

George Francis Dow's Salem in 1630. Pioneer Village from 1930 proved the value of real and replica seventeenth-century sites operated as Salem museums before the Witch House was restored. *Postcard image from John Goff collection.*

were planned, designed, fabricated and installed along state roads to identify, interpret and preserve First Period colonial historic sites, while allowing the average motorist to be charmed by historic discoveries. Regarding school programs, the MBTC also prepared new educational booklets that were distributed to public schools across the state. These fostered both a better appreciation of New England's First Period (circa 1620–1720) settlement history and new abilities to craft custom local pageants, plays, reenactments and anniversary celebrations.[36]

Grand Pageants and the *Arbella* Landing Reenactment

One of the most triumphantly spectacular and catalytic highlights of the 1930 Massachusetts tercentenary was a series of public pageants, parades and celebrations designed to reconstruct aspects of the June 1630 Governor John Winthrop Fleet arrival in Massachusetts three hundred years later—in June 1930. The State of Massachusetts holds 1630 as its founding date because in that year, Governor John Winthrop and his

many colleagues with family names of Dudley, Saltonstall, etc., sailed to Salem, Massachusetts, aboard the sturdy, three-masted ship *Arbella* with a royally signed copy of the charter for the Massachusetts Bay Company. The *Arbella* was sailed with a number of other ships, including the *Talbot*, but is remembered to have been the charter ship because it carried the parchment document that gave the Puritans in Massachusetts outside of Plymouth the ability to form a new government, economy, Massachusetts Bay Colony and civilization. Winthrop disembarked the *Arbella* first in Salem in 1630, prior to relocating his colonizing enterprise to the Shawmut Peninsula (now Boston) south of Salem.[37]

As the 1930 tercentenary approached, leading Massachusetts historians, including George Francis Dow with the Society for the Preservation of New England Antiquities (SPNEA) in Boston, began making plans for huge and spectacular reenactments to be held to allow people living in 1930 to "see" how it looked when the *Arbella* and the earliest Puritans first arrived in Salem in 1630. To support the new 1930 *Arbella* Landing pageant and reenactment plans, a portion of Forest River Park in South Salem was redeveloped in 1929–30 to show a new replicated First Period village, a Salem from 1630, that could be used as a 1930 pageant backdrop and stage setting.[38]

Using Hawthorne's *Grandfather's Chair: A History for Youth* book from 1840 as a guide, architects, landscape architects and historians were all employed to construct the village of "miserable hovels" that Salem was in its earliest years. George Francis Dow, Harlan Page Kelsey and Philip Horton Smith were three of the Colonial Revival architects and landscape architects who pooled their resources to make Pioneer Village or Dow's "Colonial Village" a huge success. As depicted in 1930s and 1940s photographs, as well as in Lewis Jesse Bridgman's perspective rendering from about 1930, Salem's Pioneer Village was a fine and progressive Massachusetts tercentenary attraction that put Salem on the map as one of the key places where tourists and school groups could come to see, touch and visit a "magical" seventeenth century–style village to better understand how conditions actually were in the earliest decades of New England's existence.

To reconstruct a seventeenth-century ship landing, a surplus two-masted gaff-rigged 1870s lumber schooner from Ellsworth, Maine (the *Lavolta*), was obtained and altered to sail anew as an *Arbella* replica, complete with three masts, square rigging and suggestions of many of the earlier features known to have been on Governor Winthrop's original *Arbella*. The replica *Arbella* was sailed to and publicly displayed in Boston and then sailed north to Salem to help thousands of visitors "experience" the sight of watching a

seventeenth century–style *Arbella* approach land, drop anchor and discharge seventeenth century–style Puritan reenactors. Although the *Arbella* replica was lost in 1954, Pioneer Village has been maintained since the 1930s. It was restored between 2003 and 2008 by Salem Preservation, Inc., and in 2009 it was reopened to the public by Gordon College's new Institute for Public History, working with History Alive!

Although most Americans remember the 1930s as a time of severe hardship, due to the Depression, Salem residents, blessed by their history and the Massachusetts tercentenary, began to develop a number of other "living history" attractions that proved to be popular with people from all over the globe. Close to the Naumkeag Steam Cotton Company mill (now Shetland Properties), where the *Lavolta* was reconfigured into a new *Arbella*, a new Colonial Revival–style Pequot House was also built in Salem in 1930 to serve as an attraction during the Massachusetts tercentenary. Named for the "Pequot" brand of cotton sheets that were manufactured in the nearby mill, the Pequot House was conceived and built to be a textiles industry display space in a replicated circa 1650 Salem merchant's home. It was built from scratch using appropriate materials and seventeenth-century timber framing methods and stands today near Congress Street and the South River as a close Colonial Revival architectural cousin of both George Francis Dow's restored John Ward House and Salem's colonial Witch House.[39]

To assist Massachusetts tercentenary visitors in better experiencing seventeenth-century life, the Essex Institute during the 1930s also provided public access to the restored John Ward House on the Essex Institute grounds south of Brown Street. Architecturally similar to both the Pequot House and the Witch House, the Ward House was and is a circa 1680 timber-framed Salem structure that was initially moved and restored to its First Period appearance under the supervision of Dow, remembered also for Pioneer Village.

East of the Pequot House, Massachusetts tercentenary visitors also thronged to see the restored House of the Seven Gables on Turner Street in Salem. This late seventeenth-century merchant's home with a commanding position on the north shore of Salem Harbor was restored about 1910 by Caroline Emmerton and her Colonial Revival architect Joseph Chandler, an MIT-trained contemporary of both George Francis Dow and Philip Horton Smith. The House of the Seven Gables has been operated as a historic site attraction for nearly one century by the House of the Seven Gables Settlement Association.[40]

During the 1930s and 1940s, at least six other history interpretive projects were started and carried out in Salem, which familiarized

THE CORNER OF NORTH AND ESSEX STREETS IN 1700

Architects Samuel Chamberlain and Walter H. Killham campaigned in the 1930s for the Witch House to be restored. This is Killham's perspective showing how he thought the Witch House (far left) and two neighboring houses first looked. *Courtesy Peabody Essex Museum.*

people with Massachusetts First Period history and demonstrated how history could be fun, and in the process it raised public expectation for the Witch House to be appreciated, restored and used as a new historic house museum. Six noteworthy projects came out of these decades: 1) early American industries and activity demonstrations held regularly at Pioneer Village through the 1930s; 2) ship *Arbella* replica permanently berthed on the beach by Pioneer Village in and after about 1937; 3) the circa 1650 Ruck House, considered to be Salem's oldest surviving First Period house, moved to and reconstructed at Pioneer Village near the *Arbella* ship replica; 4) Salem's Old Town Hall saved from demolition for parking and restored under Philip Horton Smith's guidance in the 1930s; 5) Salem's Historic Derby Wharf with adjacent Salem Customs House, etc., incorporated as the nation's first national historic site in the 1930s; and 6) Street Reenactments: a Series of Chestnut Street Days planned and held to showcase First Period and colonial costumes, traditions, carriages, etc., along Salem's most beautiful residential street—Chestnut Street.[41]

All of these significant colonial and Colonial Revival developments in Salem helped support the asking of an important new question: could Salem's ancient Witch House be similarly restored and transformed and find perpetual new value as a historic site attraction and history teaching tool?

TWO INFLUENTIAL ARCHITECTS

OF THE 1930S

Walter Kilham and Samuel Chamberlain

As a consequence of Colonial Revival enthusiasms sparked by the Massachusetts tercentenary and special events and pageants, etc., during the 1930s, two very talented and highly trained Colonial Revival architects on Boston's North Shore began to pay closer attention to the Witch House and its restoration potential: Walter H. Kilham and Samuel Chamberlain.

Walter H. Kilham (1869–1948) was a native of Beverly, Massachusetts, who trained in architecture at the prestigious Massachusetts Institute of Technology (MIT). He attended America's oldest architecture school in the early 1890s when it was headquartered in Boston's Back Bay. However, railroad connections made it easy to travel back and forth between Boston and Salem and Beverly to the north. During the 1880s and 1890s, MIT maintained a summer school in Salem at which young Colonial Revival architects in training were exposed to Salem as a "Treasure House" of colonial architecture. Students were given free rein to tour and study the details in many of Samuel McIntire's houses, as well as other old colonial landmarks, so they would learn how to design colonial replicas and new buildings for historic environments. It is likely that Walter Kilham, while still an MIT student, toured Salem's McIntire Historic District with the ancient Witch House as such a prominent landmark at Essex and North Streets.

In the architectural field, Kilham cut a high profile, and his firm Kilham & Hopkins, based in Boston, served in the 1910s to be the training ground of one of Salem's most prolific early twentieth-century Colonial Revival

architects: Philip Horton Smith, whose father J. Foster Smith served as agent of the influential Naumkeag Steam Cotton Mills (today's Shetland Properties). Kilham & Hopkins had also earned local renown in Salem for designing the first part of the Old Salem High School at Highland Avenue and Jackson Street in Salem between 1908 and 1910. Its prominent brick and terra-cotta Colonial Revival landmark here is currently functioning as the Collins Middle School.[42]

In 1933, a few years after the Massachusetts tercentenary, James Duncan Phillips, the esteemed First Period Salem historian, commissioned Kilham to produce a new illustration of Salem's downtown Essex Street during the late seventeenth century, when the Witch House was in its prime. For Phillips's book, *Salem in the Seventeenth Century*, Kilham produced a charming pencil perspective sketch that looked down the street in a northeasterly direction, showing the Witch House in the foreground, the Deliverance Parkman House next in line and a third substantial timber framed house far away, near the horizon.[43]

MIT-trained architects in the early twentieth century were routinely educated in how to construct accurate perspective sketches and renderings, looking at almost any streetscape, from any point of view. This skill was carefully taught so that designers could fairly quickly rough out the proposed massing and appearance of proposed new buildings to show clients and sponsors how new buildings fit into historic environments long before construction began. Once mastered, however, the art and technique of producing accurate perspective sketches could also be used, as Kilham demonstrated so well, to reconstruct long-lost historic urban streetscapes. When Walter Kilham produced his picturesque pencil perspective in 1933, the Witch House had been substantially altered with the 1850s Italianate drugstore addition. Kilham's sketch was far more compelling than previous renderings. It showed how the house likely looked before—without the drugstore and with its original multi-gabled First Period roof. Kilham's drawing borrowed from earlier perspective sketches—like the Bartol rendering from 1819 and the conjectural restoration sketch from circa 1885. Yet by showing more of a streetscape and a larger swath of seventeenth-century Salem, Kilham's drawing was exciting. It showed how the ancient Witch House in its First Period appearance had been part and parcel of earliest Salem, and it essentially argued for an accurate restoration of the landmark to its seventeenth-century form.

A SECOND RESTORATION ADVOCATE:
SAMUEL CHAMBERLAIN

A second professionally trained architect, who picked up Walter Kilham's implicit call to restore Salem's Witch House in the 1930s, was Samuel Vance Chamberlain (1895–1975). Born three years after the 1892 bicentennial of the Salem witch trials, Chamberlain was fully twenty-five years younger than Kilham. Originally from outside of New England—a native of Iowa as well as Washington State—Samuel Chamberlain fell in love with the historic East Coast, as well as Europe at an early age. He then became renowned as an artist, photographer and author of New England travel books in the 1930s and 1940s and helped to stimulate and earn wealth from the growing Massachusetts tourism market.[44]

Born in Cresco, Iowa, Sam Chamberlain grew up in the Pacific Northwest—mostly Washington State. In 1915, he enrolled in the architecture program at MIT in Boston, but his professional education was interrupted by World War I. In 1917, he applied for a passport to join the volunteer ambulance corps, the American Field Service working in France. At the time he described himself as twenty-one years old and five foot ten inches tall, with an oblong face, fair complexion, ash-blonde hair, blue eyes and a straight nose.

Chamberlain fell in love with France. The landscape, scenic views and ancient buildings and streetscapes all worked a spell on him. After the Great War was won, Chamberlain returned to Washington State, where he worked as a perspective artist and renderer for various architectural firms and as a commercial artist. However, in 1922, he returned to Paris and married Narcissa Gellatly ("Biscuit"), with whom he eventually raised two daughters.

In France, Chamberlain was drawn to historic streetscapes and an artist's life. During the 1920s in Paris, he studied sketching, etching and printmaking techniques under some of the best teachers available. He socialized with a number of famous American expatriates including Gertrude Stein and sculptor Alexander Calder, the etcher and lithographer as well as inventor of the mobile. In 1930, the Chamberlains purchased a house in Senlis, a small town about thirty miles north of Paris. It would appear that Chamberlain's exposure to many historic landscapes in France made him become especially sensitive to the "charm of the old," and that this in turn became his primary obsession and focus after returning to the United States.

During the 1920s and 1930s, Samuel Chamberlain earned fame as an American book publisher, author, artist and printmaker. In 1927, he

received a Guggenheim grant and moved to London, where he attended the Royal Academy. He produced two published portfolios, "Sketches of Northern Spanish Architecture" and "Domestic Architecture of Rural France." With Louis Skidmore, he also produced his first book, *Tudor Homes of England*. Chamberlain thus entered the book publishing field prior to his return to America.

One year after Walter H. Kilham produced his superb rendering of the Witch House in 1933, the Chamberlains returned to the United States and to Marblehead, originally part of seventeenth-century Salem. They lived at 31 Front Street in Marblehead and later at 7 Tucker Street while Sam Chamberlain assumed new position(s) teaching at MIT.

While Chamberlain continued to work as a printmaker, by 1935 he increasingly practiced photography. Early books of his photographs of Cape Cod and New England attractions were followed by his *American Landmark* series. Escapes North explained:

> *The small, inexpensive books that made up this series were specifically oriented to the lucrative Massachusetts tourism market. In each of these photo books Chamberlain captured the essence of the landscape and architecture of a popular tourist destination, among them Salem, Marblehead, and Nantucket.*

Many of Chamberlain's books from the mid-1930s on would be published by Hastings House, a company founded specifically by Walter Frese as an outlet for Chamberlain's work. Together they would produce four dozen books, and many of these, including *Salem Interiors*, *A Stroll Through Historic Salem* and *Southern Interiors*, were related to American colonial architecture."[45]

In 1938, just five years after Walter H. Kilham produced his fine pencil perspective drawing of a restored Witch House, Chamberlain, in his new *Historic Salem in Four Seasons* book, argued powerfully for the 1850s Victorian drugstore addition to be removed and for the Salem landmark to be fully restored. To national and international audiences who purchased his popular 1930s guidebooks during the Great Depression, Chamberlain, assuming the role of a local North Shore regional tour guide, wrote: "'The Witch House,' so called because it was the home of Jonathan Corwin, one of the judges of the witchcraft court, is still standing much as it was in 1692, save for the inglorious appendage of a Victorian drug-store."[46]

Chamberlain also photographed the ancient timber-framed mansion that had housed Davenports, Corwins, Wards and others and been a witness to

Leslie's Retreat. He showed the compromised Witch House to his book-purchasing customers so they could see (and imagine) for themselves how the house would look restored. By the early 1940s, when Chamberlain's book was well read both locally and all over the world, the stage had been set for a full restoration of the Witch House to begin. The Colonial Revival movement, started by Mary Hemenway and others, had succeeded in motivating architecture schools and historians to care for their built heritage better and to train new generations of preservationists to walk in Mrs. Hemenway's shoes. Walter H. Kilham and Samuel Chamberlain were two of the most distinguished architects and perspective renders to rise to North Shore and Boston area prominence during the 1930s. After both Kilham and Chamberlain came down strongly on the side of preserving—and restoring—the Witch House, the stage was set for accurate restorations to begin in the following decade.

PRESERVATION CRISES AND RESTORING THE WITCH HOUSE IN THE 1940S

P rior to the 1940s, many evolving contexts supported the Witch House being appreciated as a landmark, moved, saved and restored. Arguably the most important was the emergence of the Colonial Revival as a movement and architectural style, which encouraged the cherishing and replication of early building forms from the seventeenth century. The roots of this movement could be found in the early nineteenth century, when artists like Samuel Bartol began producing images showing how old landmarks like the Witch House likely first looked when new. Yet it shone most strongly after the American centennial of 1876 when Mrs. Mary Hemenway saved Boston's Old South Meeting House.

As a consequence of the growing Colonial Revival movement and the recognition of heritage tourism's economic value, many colonial buildings had been restored to their former glory by the 1940s. Miss Caroline Emmerton saved and restored Salem's House of the Seven Gables. The Ropes Mansion had been transformed into a museum, and George Francis Dow's 1680s John Ward House and Salem in 1630: Pioneer Village were successful public attractions. With Samuel Chamberlain's visibility and support, it would only prove to be a matter of time after the 1930s before preservationists turned their attention toward Salem's ancient Witch House.

Yet two noteworthy, severe national crises initially deflected public attention away from Salem and the Witch House in the 1930s and 1940s: the Great Depression and World War II. The Great Depression, tied to the Stock Market Crash of 1929, caused many architects, bankers and

professional men to lose their jobs. World War II also pulled a lot of local attention overseas as Americans came to re-learn fear of foreign enemies and to actively combat Japanese and German military advances.

Curiously, as Americans in the 1940s mobilized for World War II and retooled the American economy and manufacturing to defend national borders, they earlier, in the 1930s, began to mobilize to fight the Depression and economic recession using quasi-military methods. In 1933, one of the grandest and most ambitious "make work" Depression-era programs (that would pay fruitful dividends in the 1940s) was the Historic American Buildings Survey, also simply called HABS.

HISTORIC AMERICAN BUILDINGS SURVEY INVOLVEMENT AND SITE DOCUMENTATION

The Historic American Buildings Survey (HABS) maintained by the Library of Congress in Washington, D.C., was conceived as a federally funded make-work program to both re-employ unemployed architects in and after 1933 and produce better documentation of America's most significant historic architectural treasures. Recognizing that America's oldest and most historic landmarks were of a finite quantity and that they were threatened by many new twentieth-century urban developments— including modern highway, hotel and gas station construction projects, street widenings, etc.—the HABS program began organizing new networks of professional architects familiar with First Period buildings and resources to identify "significant" and "at-risk" resources and to move proactively to document worthy landmarks on their old sites with new measured plans and high-resolution photographs *before* ancient landmarks were simply bulldozed and lost in the name of "progress."[47]

By 1940, the New England and northeast regional office of HABS, located on Charles Street in Boston, was manned by at least two highly qualified preservation professionals. The first was Frank Chouteau Brown. Known simply as Chouteau to his friends, Brown was a Boston-based Colonial Revival architect and architectural historian. He cut his teeth preparing superb drawings of historic features in many colonial landmarks in the Northeast and also penned architectural history profiles of early Massachusetts coastal communities for *Pencil Points* magazine, the precursor to *Progressive Architecture*

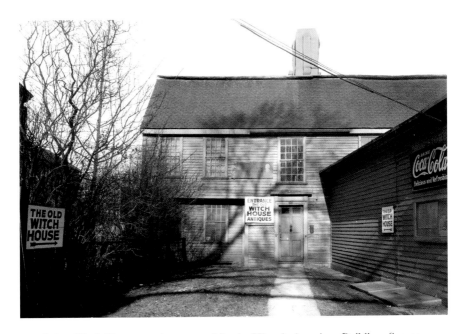

The Salem Witch House was documented for the Historic American Buildings Survey before its 1940s restoration. In this 1940 photograph taken by Frank Branzetti, we see the house was called the "Old Witch House" and contained the "Old Witch House Antiques." *Courtesy Library of Congress.*

magazine. Brown's architectural history knowledge and design and drafting skills were among the best in the whole United States. A lesser-known HABS team professional, skilled with architectural photography using large-format cameras, was Frank Branzetti. Brown and Branzetti worked together in the HABS office at the foot of Boston's Beacon Hill.

By November 1940, Brown and Branzetti's Boston HABS office evidently became quite concerned about the fate of Salem's ancient Witch House. With an office located close to the Massachusetts Statehouse in Boston, it seems likely that Brown and Branzetti routinely reviewed proposed new Massachusetts State highway construction projects to determine the adverse effects on ancient buildings and sites. Before Christmas, Branzetti, ten years Brown's junior, was dispatched by the elder preservationist to begin making new HABS-quality documentary photographs of Salem's ancient Witch House. Frank Branzetti took a first new photograph of the Witch House in late November and a second a few weeks later. With two new Branzetti photographs entered into HABS records in Boston, the Witch House became a sort of recognized American or national historic

landmark before the state's plans for widening Salem's North Street (State Route 114) were implemented.

Frank Branzetti's HABS photographs provide excellent insights concerning how the Witch House and its historic neighborhood had evolved by 1940. Over the years, much of the old Corwin property had become subdivided and used to support a dense collection of newer eighteenth- and nineteenth-century buildings on the Essex and North Street corner. The Witch House itself had become topped with a Georgian-style gambrel roof, grown an Italianate drugstore addition and been covered with an assortment of signs. The signs were a bizarre mix and included large Coca-Cola and hospital supplies advertising signs facing Essex Street, a commercial sign identifying the shop of the "Witch House Antiques" and a historic marker on the North Street gable identifying the place as the Roger Williams House—which had become painted out after that fact had been determined to be false.

DEMOLITION THREAT AND THE NEED TO MOVE THE ANCIENT HOUSE

By the spring of 1944, during World War II, Salem faced its first major demolition threat on the Witch House. North Street (State Route 114) was to be widened to accommodate more traffic. This project placed the Witch House in peril and in danger of being lost forever, along with many other buildings, including the Witch House's neighbor to the immediate west—the Bowditch House, then called the Cook House.

The potential loss of two historic Salem landmarks on the North and Essex Street corner sparked many progressive Salem citizens to work together to find a much more optimal architectural solution for a widened new North Street that would not sacrifice the Witch House. The need to primarily save the historic Witch House at its street corner was underscored by the property recently being documented by the Historic American Buildings Survey.

THE FOUNDING OF HISTORIC SALEM, INC.

Many Salem residents were mobilized to become Salem preservationists who stepped forward and contributed to the creative saving, moving and restoring of Salem's Witch House in the 1940s. Early house rescuers included Warren

Butler of the Chestnut Street Associates, Mayor Edward Coffey of the City of Salem, George Benson (son of artist Frank Benson), the first officers and organizers of Historic Salem, Inc., and Salem and Boston architect Gordon Robb (son of the well-known early twentieth-century Salem photographer Malcolm Robb).

To preserve the Witch House and Bowditch House most appropriately, this coalition of concerned Salem citizens concocted some very clever plans. First, they decided to pool public and private resources so that the resources associated with Salem City Hall and the Salem Planning Department could be combined with additional resources found in Salem as a whole. Second, they decided to clear much of the Essex and North Street corner of its later buildings both so that the new North Street widening could be accommodated—and a more historically appropriate, colonial farm field setting could be created as a new backdrop for a relocated Witch House. Last but not least, they also committed to form a new community preservation organization called Historic Salem, Inc. (HSI) to specifically oversee and coordinate many of the historic house museum needs associated with converting both the Witch House and the Bowditch House into new Salem history museums and to furnish them with the necessary displays and antiques. HSI was specifically chartered in 1944 "[t]o preserve historic sites, buildings and objects and to work for the education of the community in the true value of the same."[48]

On April 28, 1944, a meeting was held in the city council chamber of Salem City Hall to discuss the project. Warren Butler, chair of the Salem Planning Board, introduced architect Gordon Robb at this meeting. According to Salem historian James McAllister, Robb unveiled a sketch of the corner of Essex and North Streets as it would look if the buildings were relocated to allow for the widening of North Street. Mayor Coffey also proposed a forty-six-person executive committee, chaired by George Benson, to raise funds needed to relocate and restore the two Salem landmarks.

In September 1944, HSI held its first board meeting at the mayor's office in Salem City Hall. Present at this meeting were George Benson (HSI president), Warren Butler (HSI vice-president), Arthur Brennan (HSI secretary and treasurer), F. Elmer Eaton, George Parker, Harriet Rantoul, architect John Gray and architect Gordon Robb. Robb was present, it was noted, to "assist the Board in its discussions." Decisions were made to purchase the Bowditch House and land as required to move the Bowditch House north of the Witch House; to move the Witch House westerly about thirty-five feet, so as to preserve its relationship to the two adjacent street

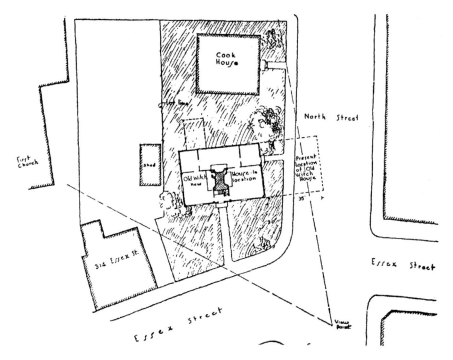

In this remarkable ca. 1945 drawing by architect Gordon Robb, we see the measured first floor plan of the Witch House at it was first proposed to be restored. Architect Gordon Robb of Salem and Boston oversaw the move and restoration of the Witch House in the 1940s. *Courtesy Historic Salem, Inc.*

edges; and finally to restore and furnish the Witch House to its seventeenth-century appearance at the new location.[49]

GORDON ROBB'S AND WILLIAM BOGART'S WITCH HOUSE WORK

Between 1944 and 1948, Gordon Robb oversaw and guided the Salem Witch House restoration project, with some consultation and support also provided by Frank Chouteau Brown. Two architectural drawings of Robb's survive from the project—a plan view and a perspective rendering. Both were likely prepared in 1944. The plan view shows quite clearly where in relation to North Street the Witch House stood before the work began and how the house was to be moved approximately thirty-five feet to the west. Prior to the project, the east end of the ancient Witch House was nearly aligned

SITE OF RESTORATION OF THE
Witch House
CIVIC PLAN FOR
FUTURE DEVELOPEMENT
OF Historic Salem

Rendering of Salem Witch House restoration project in the 1940s— conjectural sketch by Rackett Shreve. *Courtesy Rackett Shreve.*

with the center of the widened North Street, and so it is possible that portions of the old stone foundation for the house still survive beneath that street.

Gordon Robb's early floor plan prepared for the project also shows that he was originally proposing to reconstruct three rooms (probably a borning room, a kitchen and a keeler or dairy) in the rear lean-to. A restored rear lean-to kitchen was ultimately not built, in part because a new Witch House Gift Shop was built in that space. Other changes introduced during the course of the project included changing the middle bay of the house to show a projecting front porch and introducing a pair of front-facing and steep-pitched gables in the attic roof. Neither the projecting front porch nor the attic gables are seen on the perspective rendering prepared early on the job.

The Salem Witch House restoration project was initially conceived to allow both the Witch House and the Bowditch House to be utilized as restored historic house museums on a prominent corner of downtown Salem, close to the original sites for both buildings. It was complicated in that it involved building demolitions, building relocations, building moves and building restorations—all on a relatively small downtown property. Yet in time, it proved to be a very good reuse, one that is still guiding the property. Although the Witch House was fully restored and opened to the public in 1948, full restoration of the Bowditch House was delayed by post–World War II veterans' housing needs. The exterior of the Bowditch House was not fully restored to its early nineteenth-century appearance until the years between 2000 and 2003. Gordon Robb's skilled work on the Witch House restoration project resulted in him later being selected to help preserve and restore Salem's Hamilton Hall in 1947 and Salem's Pickering House in 1948.[50]

View of Witch House from Essex Street, circa 1900. *Courtesy Peabody Essex Museum.*

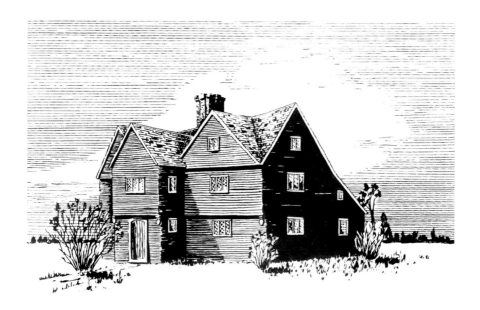

McManus Rendering of Salem Witch House, circa 1950. *Courtesy Danvers Archival Center.*

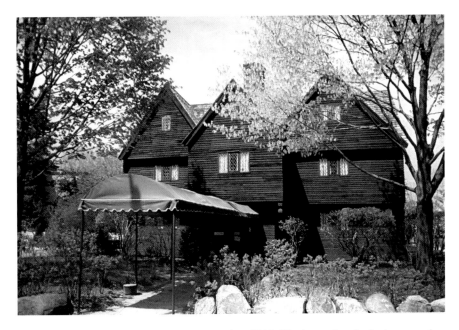

The Salem Witch House as seen in summer, circa 1980. The house then had a large awning over the front sidewalk. The awning was later removed. *Photograph by Jim McAllister.*

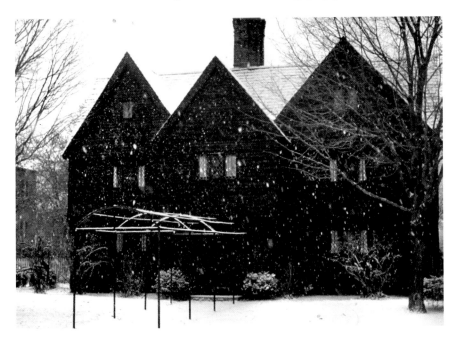

The Salem Witch House as seen in winter, circa 1980. *Photograph by Jim McAllister.*

The Witch House restoration, completed in 1948, was bid by contractor William M. Bogart of Boston. Bogart was also hired in 1945 to move the Witch House. The Bogarts recalled that the house and its chimney were moved west as a unit. William Bogart's daughter, Olive Bogart, reported that after the house and chimney were moved, the old hearths were excavated and bones were found. Whose bones they were remains a mystery. They became the subject of a new sketch prepared by Rackett Shreve for *Salem: From Naumkeag to Witch City*, printed in 2000.[51]

THE WITCH HOUSE TODAY

The so-called Witch House (or Corwin House, or Davenport-Corwin-Ward House) at Essex and North Streets in Salem remains one of America's most impressive and ancient architectural landmarks. I propose its chief significance derives from its phenomenal age. Built first before 1674 (but remodeled several times since), this post-medieval English First Period multi-gabled timber-framed structure is over three hundred years old, a true touchstone to antiquity. More than fifteen generations have passed since the first Davenports and other English colonists hand-crafted stout oak timbers here in the Puritan stronghold and cut them in such a way that they could be pegged together to create a new skeleton of a house that would be sturdy enough to endure harsh New England winters season after season.

Yet, in truth, Salem's old Witch House is a touchstone to many different pasts and many antiquities. Some have been discussed briefly already. Essex Street in front of the house started out as an Indian Trail. Over the years, it has produced unusual treasures like the Native American carving of a Naumkeag bear that provides vivid testimony to the fact that anciently the whole river-fronting landscape here was heavily wooded and part of a Native American eastern woodlands paradise. The earliest Naumkeag and native realities provide a base line of antiquity that can be recalled, interpreted and perceived at places like Salem's profound Witch House.

Challenges associated with maintaining divergent world views (one natural and native, the other English and Bible-based) colored the history of this site, structure and the families associated with this structure through

two subsequent antiquities: the realities associated with the 1675 and 1692 periods. The first was characterized by Wampanoag Metacom or King Philip's War and saw the marching off of Davenports and other English officers to attack a Narragansett stronghold to preserve a colonial ideal. The second saw Jonathan Corwin and others who lived here take sharp aim at others, the so-called accused feared to be in league with a Devil and who thus were mostly hanged at Gallows Hill. The 1670s and 1690s antiquities were radically different from the earliest Naumkeag antiquity, but they evolved and happened here nevertheless.

After the Salem witch trials, Salem's Witch House survived to see other important events develop in this neighborhood, too. During the 1740s, an aspiration for new mercantile success and style imported from England led to the Witch House being "reclothed" in a large English Georgian-style gambrel roof. Yet in 1775, Colonel Alexander Leslie from England was repulsed from the shores of the North River near this house—an important opening chapter in America's Revolutionary War.

Even after independence was won, other unique times and antiquities evolved. The mathematical genius of Nathaniel Bowditch, who resided next door to the Witch House in the early 1800s, helped Salem achieve a global maritime reach in the Federal Period that returned new riches and elegance to the old seaport of the Conants, Endicotts, Davenports and Corwins. Rich layers of legend and mystique associated with both the pre-1770s colonial period and the Federal-era days of the Great Age of Sail in time came to create a new antiquity: nineteenth- and twentieth-century generations fixated on the past and excited by the Colonial Revival.

Salem's ancient Witch House is not simply a touchstone to antiquity or to many eras; it is a landmark that provides us with something familiar through changing times. In addition, it is a window through which we can view Salem's long evolution from ancient Naumkeag over many centuries.

Salem's Witch House is a touchstone to antiquity—and more. To experience it yourself, please come visit. Contact information is provided below.[52]

The Witch House
www.corwinhouse.org
310 Essex Street, Salem, Massachusetts 01970
Voice (978) 744-8815 / Fax (978) 741-0578
Email: info@corwinhouse.org

KNOWN BIOGRAPHICAL INFORMATION ON SOME OF THE KEY WITCH HOUSE PRESERVATIONISTS OF THE 1940S

GEORGE BENSON

George Benson, eldest son of noted American impressionist artist Frank Weston Benson (1856–1951), was born in Salem, Massachusetts, about 1893. A charming young lad with blonde hair in the 1890s, he was painted in several of his father's most valued paintings, including a portrait prepared in 1896 and a turn-of-the-century Salem Harbor scene showing him standing in a sun-drenched dory. Sensitized to Salem's value as a historic seaport with through encounters with exceptional architecture in his youth, George Benson upon maturity became one of Salem's most progressive historic preservationists. In 1944, he helped found and served as first president of Historic Salem, Inc., organized to co-fund with the City of Salem the Witch House and Bowditch House restoration projects at Essex and North Streets. Through family ties to the Salem Pickerings (George's cousin Ruth Benson Pickering being married to John Pickering), George in and after the 1940s also became involved with Pickering House preservation efforts at 18 Broad Street in Salem's McIntire Historic District. George resided in a separate residence on the Pickering House property and worked with his cousin's husband John Pickering IX to establish the Pickering Foundation as nonprofit owner and manager of the seventeenth-century Pickering House in 1951. In 1962, the 1920s Colonial Revival–style Misses Pickering/George Benson House was moved from its original site at 2 Pickering Street northwest of the Pickering House to a new site on the east side of Hamilton Street close to where Ruth Benson grew up: the 7 Hamilton Street House, built for her father (George's uncle) Henry Benson. Henry Benson, born in 1867, was a Salem cotton merchant, as well as Salem's mayor in the 1910s.[53]

WILLIAM M. BOGART

William M. Bogart of Boston, born about 1874, was the contractor hired to oversee the Witch House move and restoration. He poured new concrete foundations, moved the Bowditch and Witch Houses to new concrete foundations and then restored both buildings in their new locations. While complete drawings and specifications relating to the 1940s Witch House project have never been found, it would appear that the Witch House work also involved jacking the old house up in the air, setting it upon steel beams and rollers or blocks prior to the move, replacing wood sills and other decayed wooden structural members as needed, removing the eighteenth-century Georgian-style gambrel roof, building a new pitched roof with steep gabled dormer windows in the attic, returning all windows to leaded glass casement windows and making wall, door and other architectural repairs as required.[54]

FRANK O. BRANZETTI

Frank Onofrio Branzetti was born in Gaeto, Italy, in 1885. In 1915, while thirty years old, he was admitted as a U.S. citizen. He then resided at 1266 Boylston Street in Brookline, Massachusetts, and worked as an automobile chauffeur. Three years later, he found employment as an "assembler." Five foot, eight inches tall, with a dark complexion, brown eyes and brown hair, Frank Branzetti grew up in the Greater Boston area between the 1910s and 1940s. After the Historic American Buildings Survey (HABS) program was created in 1933, he proved himself to be one of the nation's leading photographers of historic buildings, colonial milestones and ancient sites. When he was fifty-five years old, Mr. Branzetti made two visits to Salem, evidently armed with a large professional view camera, tripod and four- by five-inch film packs. Mr. Branzetti photographed the old front door of the Witch House in late November 1940 and the North Street façade about one week later.

FRANK CHOUTEAU BROWN

Frank Chouteau Brown (1876–1947), also simply called "Chouteau" by his friends, was one of Boston's and America's leading Colonial Revival and

restoration architects in the late nineteenth and early twentieth centuries. Renowned for his superb drafting skills, as well as for his extensive knowledge of New England architectural history, Brown long maintained a private practice in Boston while he also produced illustrations for *Pencil Points* (the forerunner of *Progressive Architecture*) and wrote historical articles for the White Pine monographs, which set the early twentieth-century standard for architectural history scholarship in the Colonial Revival era.

Born in Minneapolis, Minnesota, in the nation's centennial year, Brown was educated at the Minneapolis School of Fine Arts and the Boston Art Club, as well as in Europe. Historians have noted: "In 1902 he [Brown] began practice in Boston and from 1907 to 1919 was editor of the *Architectural Review* periodical. In 1916 he became a member of the faculty of Boston University and in 1919 head of the department of art and architecture." His publications include:

Letters and Lettering (1902)
The Orders of Architecture (1904)
New England Colonial Houses (1915)
Modern English Churches (1917)
The Brick House (1919)[55]

Census records indicate Frank Chouteau Brown resided in Boston in 1910, 1920, and 1930, and before 1920 married Mabel Franklin, a Massachusetts native. By 1930, Frank, Mabel and her sister Lillian all resided at 16 Brimmer Street in Boston. He consistently listed his profession as "Architect."

In 1940, Frank Chouteau Brown was sixty-four years old. He headed up the HABS office on Charles Street in Boston. His job here primarily was to record historic American buildings and landmarks of major significance— especially those that might be endangered with loss. Assisting him in his efforts was Frank Branzetti, nearly ten years his junior.[56]

GORDON ROBB

Gordon Robb (1888–1974), three years younger than Frank Branzetti, was an MIT architecture school graduate in the class of 1913. He was also a Salem lad of French-Canadian descent who was a son of Malcolm E. and Elizabeth Robb. It is possible that the Branzetti and Robb families knew each other before Gordon Robb was engaged to work on the

Witch House. Malcolm Robb, Gordon's father, had won early acclaim as a professional photographer in Granby, east of Montreal, Canada, before relocating to Salem, Massachusetts, to continue his work in the photography field circa 1898.

By 1904, when he was sixteen, young Gordon Robb enrolled to learn architecture at MIT in Boston. Robb remained a student of architecture at MIT for most, if not all, of the period between 1904 and 1913. In 1912, he was additionally employed as an architect in Pittsburg, Pennsylvania, and he remained employed as a Boston architect until about 1919. Gordon Robb received a very solid training in Colonial Revival style and design while at MIT, married his first wife Elizabeth (Lizzie) Johnson in Salem in 1915 and by 1916 began building Colonial Revival houses for Salem after Salem's Great Fire—including the house for James L. Roope at 43 Bay View Avenue in the Salem Willows.

Following his first wife's death in 1919, Gordon Robb married Clara van Cor in 1921. Clara grew up in Lawrenceville, Quebec, and thus shared Gordon Robb's Canadian family roots. Right after marriage, the couple resided in Salem's spectacular Wedding Cake (or Gothic Revival–style) Henry M. Brooks Cottage (built in 1851) at 260 Lafayette Street. The Gothic style likely further enhanced Robb's appreciation of ancient and traditional buildings. In 1921, he produced another of his finest early Colonial Revival houses—the Addie F. Hooper House at 17 Lafayette Place, located in south Salem north of the Brooks Cottage.

Between 1922 and 1944, Gordon Robb maintained a professional architectural office in Boston, moved to fashionable Winchester, Massachusetts, and was increasingly called upon to assist with historic projects and museums. For example, he is credited with having served as consultant to the creation of Colonial Williamsburg in Virginia and with having worked on at least three historic restorations in Dennis and South Dennis on Cape Cod (the Jericho House and Barn Museum; the South Dennis Library addition; and the restoration of South Dennis Congregational Church). In addition, he and his family moved to Cape Cod in 1940, and Robb evidently commuted from South Dennis, Massachusetts, when called upon to provide support for the Salem's Witch House project.[57]

Notes

Author's Note

1. For histories of the Lindall-Gibbs, Bowditch and Witch Houses, see Bryant F. Tolles Jr., with Carolyn K. Tolles, *Architecture in Salem: An Illustrated Guide* (Hanover, NH: University Press of New England, 2004); Historic Preservation & Design [John Goff], *Historic Structure Report for Bowditch House*, prepared for Historic Salem, Inc., and the City of Salem (Salem, MA: Historic Salem, Inc., 1999).

Introduction

2. Witch House contact information from Witch House brochure distributed at the Witch House, 2009, is reproduced on page 108 of this book.

Chapter 1

3. Algonkian place name translations from John Goff's unpublished *Dictionary of Native Place Names in New England*, prepared 1991–95.
4. Nathaniel Hawthorne, "A Rill from the Town Pump" from *Twice-Told Tales* as reproduced here: http://www.online-literature.com/hawthorne/3017.
5. For more on native Naumkeag, see John V. Goff and Alan M. Young, "Nouveau France Versus New England," *SEXTANT* XVI, no. 1 (Spring 2008); also see John V. Goff, "Remembering Nanepashemet and the Tarratines," New England Antiquities Research Association *NEARA Journal* 39, no. 2 (Winter 2005).

6. For more on native Naumkeag, see author's columns on Naumkeag and Nanepashemet in *Salem Gazette*; Goff and Young, "Nouveau France Versus New England," *SEXTANT* XVI, no. 1 (Spring 2008); also see architecturally similar village at Wampanoag Homesite, Plimoth Plantation, Plymouth, Massachusetts.

CHAPTER 2

7. For more on Tarratine Wars, see Goff, "Remembering Nanepashemet and the Tarratines," New England Antiquities Research Association *NEARA Journal* 39, no. 2 (Winter 2005).
8. For more on Gardners and Whites, see John Goff, "A Look at Salem's Beginnings—The White and Gardner Families' Contributions," Preservation Perspective, *Salem Gazette*, December 28, 2007.
9. See Historic Preservation & Design [John Goff], *Historic Structure Report for Elder James Blake House in Dorchester, MA—Oldest House in Boston*; see also Goff, "A Look at Salem's Beginnings," 2007.
10. Dr. Charles H. Levermore paper on John White, 1912, filed with Salem Public Library.
11. See Sidney Perley, *History of Salem* (in three volumes), http://etext.virginia.edu/salem/witchcraft/Perley.
12. For more on Salem's seventeenth-century development, see Perley, *History of Salem*; James Duncan Phillips, *Salem in the Seventeenth Century* (Boston, MA: Houghton Mifflin Co., 1933).
13. Nathaniel Hawthorne, "A Rill from the Town Pump" from *Twice-Told Tales*.
14. Davenport data largely extracted from records pertaining to settlement of Dorchester, Massachusetts, where the family was also influential. See records at Dorchester Historical Society, 195 Boston Street, Dorchester (Boston), MA, 02125; Dorchester Atheneum, http://www.dorchesteratheneum.org.

CHAPTER 3

15. Builder's contract language reproduced in Bryant Tolles, *Architecture in Salem*; Abbott Lowell Cummings materials.
16. Allerdale Borough Council, *Workington Hall Visitor's Guide* (Allerdale, England: Heritage and Arts, n.d.), as reproduced here: http://www.allerdale.gov.uk/leisure-and-culture/museums-and-galleries/workington-hall.aspx.
17. *Diary of William Bentley*, Vol. 2, 1793–1802, 259–60, and portrait reprinted opposite p. 453; Corwin materials on file at Peabody Essex Museum, Phillips Library.

18. "Historical Sketch of Watertown, Massachusetts," http://history.rays-place.com/ma/middlesex/watertown.htm; Greenough family records, John Goff files.

Chapter 5

19. Samuel Curwen Journal, as reprinted in Historic Preservation & Design [John Goff], *Historic Structure Report for Bowditch House*, 1999.
20. Jim Deetz, *In Small Things Forgotten: The Archeology of Early American Life* (New York: Anchor Books, 1977); material from author's lectures on American architectural styles given to Boston By Foot tour guide audiences.
21. For more information on all these buildings, see Tolles, *Architecture in Salem*, 2004.

Chapter 6

22. K. David Goss, et al., *Handbook 126: Salem: Maritime Salem in the Age of Sail* (Washington, D.C.: National Park Service, 1987).
23. For more on McIntire, see Tolles, *Architecture in Salem*, 2004; Samuel McIntire Historic District Walking Tour brochure; John Goff, "Happy Birthday, Samuel McIntire," Preservation Perspective, *Salem Gazette*, January 12, 2007; chapter on Salem architecture in Joseph Flibbert, et al., *Salem: Cornerstones of a Historic City* (Beverly, MA: Commonwealth Editions, 1999); John V. Goff, "Salem as Architectural Mecca," *Salem: Place, Myth and Memory*, edited by Dane Morrison and Nancy Lusignan Schultz, 2004; Dean Lahikainen, *Samuel McIntire: Carving an American Style* (Salem, MA: Peabody Essex, 2008); Fiske Kimball, *Mr. Samuel McIntire, Carver, the Architect of Salem* (Salem, MA: Essex Institute 1940); Frank Cousins and Phil Madison Riley, *The Woodcarver Of Salem: Samuel McIntire, His Life And Work* (New York: Little, Brown & Co., 1916, reprinted 2009).
24. For more on Corné, see Philip Chadwick Foster Smith, and Nina Fletcher Little, *Michele Felice Corné: Versatile Neapolitan Painter*, summer exhibition catalogue (Salem, MA: Peabody Museum of Salem, 1972).
25. Abbott Lowell Cummings, *The Framed Houses of Massachusetts Bay 1625–1725*, 1979.
26. John Goff, "A Fuller Look at the COA Building" [part 1 on Enoch Fuller], Preservation Perspective, *Salem Gazette*, February 9, 2007; John Goff, "A 'Fuller' Plate: Family Designed COA, Other City Landmarks" [part 3 on Enoch Fuller], Preservation Perspective, *Salem Gazette*, March 9, 2007; John Goff, "Maine Discovery Unlocks Salem History: The Fullers Were Pioneering Victorian Architects, Built COA Building" [part 2 on Enoch Fuller], Preservation Perspective, *Salem Gazette*, March 2, 2007.
27. Personal analysis of 1872 and 1876 photographs of Witch House.

CHAPTER 7

28. See Mrs. Mary Hemenway materials in John Goff, "2005 Marks Bicentennial of Augustus Hemenway's Birth in Salem," *Salem Preservationist* 3, no. 3 (October 2005) and John Goff, "SPI President John Goff Speaks about Salem Preservationist Mary Hemenway," *Salem Preservationist* (July 2004), 3, www.salempreservation.org and notes in John Goff's possession from John Goff lecture on Mrs. Mary Hemenway delivered at Salem NPS Visitors Center.

29. Ibid.

30. New England Historical Genealogical Society [NEHGS] promotional materials on website http://www.newenglandancestors.org and at headquarters in Boston, Massachusetts.

31. From SPNEA and SPAB history discovered while researching George Francis Dow, who worked for SPNEA in Boston after working in Salem; see materials of Society for Preservation of New England Antiquties (SPNEA) now Historic New England, located at Harrison Gray Otis House, Cambridge Street, Boston, Massachusetts.

32. Edwin Whitefield, *The Homes of Our Forefathers in Massachusetts* (N.p., 1892).

33. *Salem City Directory*, 1901–2, Salem Room, Salem Public Library, and analysis of old Witch House photographs.

34. Personal analysis of old photographs of Witch House and old Witch House postcards, private collection of John Goff.

35. See John Goff file on Philip Horton Smith, in possession of John Goff, Salem, Massachusetts; John Goff, "Recalling Smith & Walker," Preservation Perspective, *Salem Gazette*, February 1, 2008.

36. Massachusetts Bay Tercentenary Commission materials, John Goff collection.

37. See 1630 and 1930 research notes from materials collected by and for Salem Preservation, Inc.; analysis of old postcards and *Salem Evening News* from 1930s era; website of the Winthrop Society materials pertaining to first *Arbella* fleet ship crossing in 1630, http://www.winthropsociety.com/ships.php.

38. John Goff, "Salem's Most Famous Historian" [George Francis Dow], Preservation Perspective, *Salem Gazette*, 2007; research conducted by author for Salem Preservation, Inc., prior to restoration of Pioneer Village, 2003–8, in possession of John Goff, Salem, Massachusetts.

39. For more on the 1930 creation of Salem in 1630: Pioneer Village and the Pequot House project prepared during the Massachusetts Tercentenary, see Philip Horton Smith materials and files in John Goff collection and research conducted by Goff for Salem Preservation, Inc., prior to restoration of Pioneer Village, 2003–8.

40. John Goff, "Chandler Restored Salem's Past," Preservation Perspective, *Salem Gazette*, July 13, 2007.

41. See research conducted by Goff for Salem Preservation, Inc., prior to restoration of Pioneer Village, 2003–8; notes for Jim McAllister's class, Salem 101, notes in possession of John Goff, Salem, Massachusetts.

CHAPTER 8

42. See Kilham references in Tolles, *Architecture in Salem*, 2004; Kilham material on file at Beverly Historical Society, Beverly, Massachusetts.

43. Phillips, *Salem in the Seventeenth Century*, 1933.

44. Jim McAllister file information on Samuel Chamberlain, in possession of Jim McAllister, Salem, Massachusetts.

45. Samuel Chamberlain, *Historic Salem in Four Seasons* (New York: Hastings House, 1938); Samuel Chamberlain, *A Stroll Through Historic Salem* (New York: Hastings House, 1969).

46. Chamberlain, *Historic Salem in Four Seasons*, 1938.

CHAPTER 9

47. Historic American Buildings Survey, Library of Congress, Washington, D.C.

48. Jim McAllister, *A Brief History of Historic Salem, Inc., Salem, Massachusetts*, fiftieth anniversary booklet 1944–94 (Salem, MA: Historic Salem, Inc., 1994).

49. Ibid.

50. See Historic Preservation & Design [John Goff], *Historic Structure Report for Bowditch House*, 1999.

51. Jim McAllister, *Salem: From Naumkeag to the Witch City*.

CHAPTER 10

52. Witch House brochure distributed at site in 2009.

APPENDIX

53. Benson research first advanced by John Goff between 1998 and 2007 while d/b/a Historic Preservation & Design and preparing *Historic Structure Report for Bowditch House* and *Historic Structure Report for Pickering House*, Salem, Massachusetts.

54. For additional information on Bogart, see Jim McAllister file information on the Witch House.

55. Frank Chouteau Brown information from books cited; "Frank Chouteau Brown," Wikipedia, the free encyclopedia, http://en.wikipedia.org/wiki/Frank_Chouteau_Brown.

56. Brown and Branzetti research first advanced by John Goff between 2004 and 2007 while d/b/a Historic Preservation & Design and preparing *Historic Structure Report for Elder James Blake House in Dorchester, Massachusetts—Oldest House in Boston.*

57. Gordon Robb information researched by John Goff and others for Witch House and also for John Goff d/b/a Historic Preservation & Design, *Historic Structures Report for Pickering House.*

BIBLIOGRAPHY

Because I propose that the Salem Witch House can be appreciated as a piece of historic architecture, as a connection to 1692 and also as a window through which one can study all of Salem's early evolution, this bibliography is arranged in three parts: Salem histories; Salem and Witch House architectural histories; and Salem witch hysteria histories. I encourage further explorations in all these areas.

SALEM HISTORIES

Chamberlain, Samuel. *Historic Salem in Four Seasons*. New York: Hastings House, 1938.

————. *A Stroll Through Historic Salem*. New York: Hastings House, 1969.

Deetz, Jim. *In Small Things Forgotten: The Archeology of Early American Life*. New York: Anchor Books, 1977.

Essex Institute Historical Collections volumes, Salem Public Library, Salem, Massachusetts.

Flibbert, Joseph, et al. *Salem: Cornerstones of a Historic City*. Beverly, MA: Commonwealth Editions, 1999.

Goff, John. "Aboard the *Arbella*: The Ship that Carried the Colony's Charter." Preservation Perspective. *Salem Gazette*, March 21, 2008.

———. "Appreciating Salem's Ancient Bridge Street." Preservation Perspective. *Salem Gazette,* June 22, 2007.

———. "Chandler Restored Salem's Past." Preservation Perspective. *Salem Gazette,* July 13, 2007.

———. "City Should Embrace Naumkeag History." Preservation Perspective. *Salem Gazette,* April 6, 2007.

———. "Down the Ways: Ships Built for Salem." Preservation Perspective. *Salem Gazette,* February 15, 2008.

———. "The Ebb and the Flow: Salem Tides and Tide Mills." Preservation Perspective. *Salem Gazette,* November 10, 2006.

———. "Feeling for Joseph B. Felt: A Look at Salem's Early Historian and Antiquarian." Preservation Perspective. *Salem Gazette,* November 23, 2007.

———. "Flintknapping in Native Naumkeag." Preservation Perspective. *Salem Gazette,* August 8, 2008.

———. "A Fuller Look at the COA Building" [part 1 on Enoch Fuller]. Preservation Perspective. *Salem Gazette,* February 9, 2007.

———. "A 'Fuller' Plate: Family Designed COA, Other City Landmarks" [part 3 on Enoch Fuller]. Preservation Perspective. *Salem Gazette,* March 9, 2007.

———. "Going to Pot: Artisan Kerri Helme's Pottery Reveals Native Traditions." Preservation Perspective. *Salem Gazette,* December 12, 2008.

———. "Happy Birthday, Samuel McIntire." Preservation Perspective. *Salem Gazette,* January 12, 2007.

———. "Honoring Salem's Earliest Multicultural Origins." Preservation Perspective. *Salem Gazette,* October 22, 2006.

———. "A Landmark Year: Milestones are marked for Pioneer Village, the *Arbella* and More." Preservation Perspective. *Salem Gazette,* January 18, 2008.

———. "Leaving a Legacy: Conservationist Harlan Page Kelsey." Preservation Perspective. *Salem Gazette,* August 17, 2007.

———. "A Look at Salem's Beginnings—The White and Gardner Families' Contributions." Preservation Perspective. *Salem Gazette,* December 28, 2007.

———. "Maine Discovery Unlocks Salem History: The Fullers Were Pioneering Victorian Architects, Built COA Building" [part 2 on Enoch Fuller]. Preservation Perspective. *Salem Gazette,* March 2, 2007.

———. "Nanepashemet in Naumkeag." Preservation Perspective. *Salem Gazette,* May 9, 2008.

———. "Naumkeag: A Taste of Old Times." Preservation Perspective. *Salem Gazette*, November 7, 2008.

———. "Naumkeag Past, Naumkeag Future?" Preservation Perspective. *Salem Gazette*, August 1, 2008.

———. "No Ifs or Butts: Smoking and Salem's Great Fire," Preservation Perspective. *Salem Gazette*, November 30, 2007.

———. "Not as Puritanical as You Think: North Shore Band Sheds Light on Historical Myth." Preservation Perspective. *Salem Gazette*, August 3, 2007.

———. "Of Weirs, Fish and Cats: In Honor of Archaeology Month… American Indian Legacy at Cat Cove." Preservation Perspective. *Salem Gazette*, October 5, 2007.

———. "Our Maritime History: Fish, Boats and Salt in Naumkeag and Earliest Salem." Preservation Perspective. *Salem Gazette*, November 3, 2006.

———. "A Plethora of Pioneer Villages." Preservation Perspective. *Salem Gazette*, February 2, 2007.

———. "Preservation Vision: Pioneer Village as an Educational Site." Preservation Perspective. *Salem Gazette*, August 10, 2007.

———. "Preserving the Proud Pickering House of Salem." Preservation Perspective. *Salem Gazette*, December 8, 2006.

———. "Recalling Smith & Walker." Preservation Perspective. *Salem Gazette*, February 1, 2008.

———. "Reconstructing Salem's Lost Early History." Preservation Perspective. *Salem Gazette*, October 3, 2008.

———. "Remembering the Astounding *Arbella*." Preservation Perspective. *Salem Gazette*, November 17, 2006.

———. "Remembering the Tarratines and Nanepashemet: Exploring 1605–1635 Tarratine War Sites in Eastern Massachusetts." New England Antiquities Research Association *NEARA Journal* 39, no. 2 (Winter 2005): 3–21.

———. "Salem Discovers Lewis Jesse Bridgman." Preservation Perspective. *Salem Gazette*, January 11, 2008.

———. "Salem: Museum Capital of Massachusetts?" Preservation Perspective. *Salem Gazette*, November 16, 2007.

———. "Salem's Forgotten French Heritage." Preservation Perspective. *Salem Gazette*, June 6, 2008.

———. "Salem's Illustrious Illustrator: Lewis Jesse Bridgman." Preservation Perspective. *Salem Gazette*, March 16, 2007.

———. "Salem's Most Famous Historian" [George Francis Dow]. Preservation Perspective. *Salem Gazette*, January 5, 2007.

———. "Salt of the Earth: Salem's Seamen and the Age of Sail" [Bertram]. Preservation Perspective. *Salem Gazette*, February 16, 2007.

———. "Saturday Is Native American Day at Pioneer Village." Preservation Perspective. *Salem Gazette*, September 26, 2008.

———. "Schooners and Yachts: Recalling Salem Shipbuilder Joshua Brown." Preservation Perspective. *Salem Gazette*, December 7, 2007.

———. "The Second Passing of Samuel McIntire: After the PEM Exhibit: Next Steps." Preservation Perspective. *Salem Gazette*, February 8, 2008.

———. "Ships Ahoy: Wood Shipbuilding in Early Salem." Preservation Perspective. *Salem Gazette*, March 23, 2007.

———. "Some Naumkeag Spring Reflections." Preservation Perspective. *Salem Gazette*, April 20, 2007.

———. "Time Traveling in Salem…Salem as New England's Treasure House." Preservation Perspective. *Salem Gazette*, July 20, 2007.

———. "Tricks and Treats…and understanding Salem's Great Fire." Preservation Perspective. *Salem Gazette*, October 31, 2008.

———. "What Is a Shallop? Boats Are Key to Salem's Maritime Heritage." Preservation Perspective. *Salem Gazette*, November 24, 2006.

———. "Who Were the Naumkeag Natives?" Preservation Perspective. *Salem Gazette*, December 26, 2008.

Goff, John V., and Alan M. Young. "Nouveau France Versus New England: 17th Century Conflicts in Naumkeag (Ancient Salem)." Salem State College magazine *Sextant* XVI, no. 1 (Spring 2008): 12–20.

Goss, K. David, et al. *Handbook 126: Salem: Maritime Salem in the Age of Sail.* Washington, D.C.: National Park Service, 1987.

Hawthorne, Nathaniel. "A Rill From the Town Pump." *Twice-Told Tales* 1837, 1851. http://ibiblio.org/eldritch/nh/ttt.html.

———. *The Whole History of Grandfather's Chair Complete in Three Parts.* Boston: E.P. Peabody, as reproduced at http://www.pagebypagebooks.com/Nathaniel_Hawthorne/Grandfathers_Chair.

Historic Preservation & Design [John Goff], *Historic Structure Report for Elder James Blake House in Dorchester, MA; 2007.*

Historic SALEM Massachusetts. Boston, MA: Bromley & Company, Inc., 1970.

McAllister, Jim. *A Brief History of Historic Salem, Inc., Salem, Massachusetts.* Fiftieth anniversary booklet 1944–94. Salem, MA: Historic Salem, Inc., 1994.

———. *Salem: From Naumkeag to Witch City.* Beverly, MA: Commonwealth Editions, 2000.

Perley, Sidney. *The History of Salem, Massachusetts* [in three volumes]. http://etext.virginia.edu/salem/witchcraft/Perley.

Phillips, James Duncan. *Salem in the Seventeenth Century*. Boston, MA: Houghton Mifflin Co., 1933.

Randall, Peter E. *Salem and Marblehead*. Camden, ME: Downeast Books, 1983.

Robotti, Frances Diane. *Chronicles of Old Salem*. New York: Bonanza Books, 1948.

———. *Whaling and Old Salem*. New York: Bonanza Books, 1962.

The [Salem] Club. *Sketches About Salem People*. Salem, MA: [Salem] Club, 1930.

Salem Preservationist newsletters, published on www.salempreservation.org.

Smith, Philip Chadwick Foster, and Nina Fletcher Little. *Michele Felice Corné: Versatile Neapolitan Painter*. Summer exhibition catalogue. Salem, MA: Peabody Museum of Salem, 1972.

SALEM AND WITCH HOUSE ARCHITECTURAL HISTORIES

Assessor's Records, Salem City Hall, Massachusetts.

Cousins, Frank, and Phil M. Riley. *The Colonial Architecture of Salem*. Mineola, NY: Dover Publications, Inc., 2000, reprint 1917.

———. *The Woodcarver of Salem: Samuel McIntire, His Life and Work*. New York: Little, Brown & Co., 1916, reprinted 2009.

Cummings, Abbott Lowell. *The Framed Houses of Massachusetts Bay, 1625–1725*. Cambridge, MA: Harvard University Press, 1979.

Essex County Deeds at Registry of Deeds, Salem, Massachusetts.

Goff, John. "More to the Story: Col. Alexander Leslie's Retreat." Preservation Perspective. *Salem Gazette*, February 29, 2008.

———. "Remembering Roger Williams in Salem." Preservation Perspective. *Salem Gazette*, October 17, 2008.

———. "Salem as Architectural Mecca." In *Salem: Place, Myth and Memory*, edited by Dane Morrison and Nancy Lusignan Schultz. Lebanon, NH: University Press of New England, 2004.

———. "Salem's Controversial Landmark: The So-called Witch House Holds Many Secrets." Preservation Perspective. *Salem Gazette*, July 18, 2008.

———. "Which House? Salem Looks Anew at its Witch House." Preservation Perspective. *Salem Gazette*, October 19, 2007.

Historic Preservation & Design [John Goff]. *The Nathaniel Bowditch House Historic Structure Report*. Prepared for Historic Salem, Inc., and the City of Salem. Salem, MA: Historic Salem, Inc., 1999.

Kampas, Barbara Pero. *The Great Salem Fire of 1914*. Charleston, SC: The History Press, 2008.

Kimball, Fiske. *Mr. Samuel McIntire, Carver, the Architect of Salem*. Salem, MA: Essex Institute, 1940.

Lahikainen, Dean. *Samuel McIntire: Carving an American Style*. Salem, MA: Peabody Essex, 2007.

McAllister, Jim. Unpublished file material pertaining to the history of the Witch House, in possession of Jim McAllister, Salem, Massachusetts.

Samuel McIntire Historic District Walking Tour brochure.

Schier, Stephen J., and Kenneth C. Turino. *Images of America: Salem, Massachusetts*. Charleston, SC: Arcadia, 1996.

———. *Images of America: Salem, Massachusetts*. Vol. II. Charleston, SC: Arcadia, 1998.

Tolles, Bryant F., Jr., with Carolyn K. Tolles. *Architecture in Salem: An Illustrated Guide*. Hanover, NH: University Press of New England, 2004, reissue of 1983 book.

Whitefield, Edwin. *The Homes of Our Forefathers in Massachusetts*. N.p., 1892.

Witch House vertical file at Salem Public Library.

Salem Witch Hysteria Histories

Aaronson, Marc. *Witch-Hunt: Mysteries of the Salem Witch Trials*. New York: Simon & Schuster, 2003.

Boyer, Paul, and Stephen Nissenbaum. *Salem Possessed: The Social Origins of Witchcraft*. Cambridge, MA: Harvard University Press, 1974.

———. eds. *The Salem Witchcraft Papers: Verbatim Transcripts of the Legal Documents of the Salem Witchcraft Outbreak of 1692*. Three vols. New York: Da Capo Press, 1977.

Brown, David C. *A Guide to the Salem Witchcraft Hysteria of 1692*. Worcester, MA: Mercantile Printing Company, 1984.

Burr, George Lincoln, ed. *Narratives of the New England Witchcraft Cases*. Mineola, NY: Dover Publications Inc., 2002. First published 1914.

Francis, Richard. *Judge Sewall's Apology: The Salem Witch Trials and the Forging of an American Conscience*. New York: Harper Collins Publishers, 2005.

Goff, John. "Salem Witch Judge and the Puritan Mind." Preservation Perspective. *Salem Gazette*, March 7, 2008.

Goss, K. David. *The Salem Witch Trials: A Reference Guide.* Salem, MA, 2007.

Hill, Frances. *Hunting For Witches: A Visitor's Guide to the Salem Witch Trials.* Beverly, MA: Commonwealth Editions, 2002.

————. *The Salem Witch Trials Reader.* Salem, MA, 2000.

Hoffer, Peter Charles. *The Salem Witchcraft Trials: A Legal History.* Lawrence: University Press of Kansas. 1997.

Mather, Cotton. *On Witchcraft.* New York: Dover Publications, 2005, originally printed in 1692.

Nevins, Winfield S. *Witchcraft in Salem Village in 1692.* Salem, MA: Salem Press Company, 1916.

Richardson, Katharine W. *The Salem Witchcraft Trials.* Salem, MA: Essex Institute, 1983.

Roach, Marilynne K. *Gallows and Graves: The Search to Locate the Death and Burial Sites of the People Executed for Witchcraft in 1692.* Watertown, MA: Sassafras Grove Press, 1997.

————. *The Salem Witch Trials: A Day-by-day Chronicle of a Community Under Siege.* New York: Cooper Square Press, 2004.

————. *A Time Traveler's Maps of the Salem Witchcraft Trials.* Salem, MA, 1991.

Rosenthal, Bernard. *Salem Story.* New York: Cambridge University Press, 1993.

Starkey, Marion L. *The Devil in Massachusetts: A Modern Enquiry into the Salem Witch Trials.* New York: Alfred Knopf, 1949, 1969.

Trask, Richard B. *"The Devil hath been Raised": A Documentary History of the Salem Village Witchcraft Outbreak of March 1692.* 1992. Danvers, MA: Yeoman Press, 1998.

Upham, Charles W. *Salem Witchcraft.* Vols. I and II. Sulphur Springs, TX: Echo, 2005.

Wright, John Hardy. *Images of America: Sorcery in Salem.* Charleston, SC: Arcadia, 1999.

ABOUT THE AUTHOR

John V. Goff is a historian, architectural historian, restoration architect and preservation consultant who lives and works in Salem, Massachusetts. After studying history and American civilization at Brown University, concentrating in First Period New England studies, Goff worked as an architectural historian for the National Trust for Historic Preservation, Boston Landmarks Commission, Providence Preservation Society and Maine Historic Preservation Commission. He then earned his master's degree in architecture from the University of Oregon and began working as a restoration architect in Boston and Salem, Massachusetts.

In 1992, the Salem witch trials tercentenary year, Goff founded Historic Preservation & Design (HPD), a Salem-based preservation planning, restoration and consulting firm. The firm has restored many real and replica First Period (circa 1630–1730) properties, working alone and in conjunction with other firms such as Staley McDermet Associates in Salem. Recently completed HPD projects include the restoration of Boston's oldest house, the 1661 Elder James Blake House in Dorchester, Massachusetts; the restoration of the 1703 Phineas Upham House and Barn in Melrose, Massachusetts; the restoration of the circa 1720 Francis Wyman House in Burlington, Massachusetts; a Historic Structures Report for the restoration of the circa 1660 Pickering House in Salem; and preliminary planning for the restoration of Salem in 1630: Pioneer Village.

As a historian and author, Goff has written over fifty weekly "Preservation Perspective" columns for the *Salem Gazette*; "Salem as Architectural Mecca" in *Salem: Place, Myth and Memory*; and many articles in the *Salem Preservationist*.

Between 2000 and 2003, Goff served as executive director of Historic Salem, Inc., and maintained an office in the Bowditch House. Goff, with many others, founded Salem Preservation Inc. to restore Salem in 1630: Pioneer Village between 2003 and 2008. Growing interests in Massachusetts's earliest First Period history further led Goff to produce Native American history materials for the Salem State College *Sextant* magazine in 2008 and to the town of Ipswich, Massachusetts, for its 375th anniversary year in 2009. Goff also commenced working in 2009 to establish a new Naumkeag Museum/Education Center to better document, interpret and preserve Salem's earliest Native American history, known to date back at least three thousand years.